IMAGES
of America
LOST MOUNT PROSPECT

On the cover: William Busse's store and Buick dealership is in its original home at 2 West Busse Avenue in 1915. The building was constructed in 1912 and was the home to many local businesses over the years. The building is scheduled to be demolished in 2006. (Courtesy of the Mount Prospect Historical Society.)

IMAGES of America
LOST MOUNT PROSPECT

Gavin W. Kleespies

Copyright © 2006 by Gavin W. Kleespies
ISBN 0-7385-4091-9

Published by Arcadia Publishing
Charleston SC, Chicago IL, Portsmouth NH, San Francisco CA

Printed in the United States of America

Library of Congress Catalog Card Number: 2006929829

For all general information contact Arcadia Publishing at:
Telephone 843-853-2070
Fax 843-853-0044
E-mail sales@arcadiapublishing.com
For customer service and orders:
Toll-Free 1-888-313-2665

Visit us on the Internet at http://www.arcadiapublishing.com

This book is dedicated to Gabriel Amber Robinson and everyone who has ever tried to save something beautiful.

CONTENTS

Introduction 7

1. Productive Past 9

2. Lost Businesses 33

3. Lost Houses 57

4. Lost Public Spaces 73

5. Lost But Not Gone 97

ACKNOWLEDGMENTS

I would like to thank Jean Murphy, Marilyn Genther, and Frank Corry for their editorial assistance. I would also like to thank Cindy Bork for keeping work fun.

INTRODUCTION

The history of Mount Prospect is, in some ways, the victim of Mount Prospect's history. Mount Prospect is older than many think. The community goes back to the 1840s, and this fact is often overlooked. The village has a fascinating legacy as an immigrant community, an ambitious small town, an early progressive suburb, and a classic postwar community. However, few of today's residents are aware of this legacy. Much of Mount Prospect's past has been overshadowed by the incredibly rapid development of the 1950s and 1960s. The population of Mount Prospect in 1950 was around 4,000 people; by 1960 the population was almost 19,000. That is almost a 400 percent increase in population in one decade. This amazingly rapid development fundamentally changed how Mount Prospect saw itself and redefined the community's landscape. Many of the older buildings were demolished to make way for new developments or were modernized and are now hard to identify. The farms and early industries were replaced with houses and shopping areas. By the time this rapid development was over, it was hard to see what had been here before. *Lost Mount Prospect* is an examination of this history. It is a look at the village through the lens of what is not here anymore.

Once upon a time, Mount Prospect was an exclusively German-speaking community. Residents spoke German over the dinner table, business was conducted in German, and church services were given in German. In the early 20th century, community leaders courted industrial producers, trying to convince them to move their factories to Mount Prospect. In the 1920s, Mount Prospect was on the cutting edge of residential development, the village even adopted the slogan "Mount Prospect: City of Progress." The rapid development of the postwar era also has a fascinating and controversial history. However, the speed of this development, the culture of the time, the infrastructure that was constructed, and the types of development that were encouraged by state and federal policy led to there being little interest in integrating the new development with the existing buildings or preserving the community that already existed. Because there was not a focus on preserving or highlighting the history of the community, much of it has been obscured. While some of the history is still here, it is covered, and it is hard to see it today. Because of this, many feel that Mount Prospect has always been what it is today: a residential, suburban community.

There are a number of other books on the history of buildings that have been demolished. Most of these books focus on the major cities in America: Chicago, New York, Boston, and so on, but this book was written from a slightly different point of view. Mount Prospect has a different relationship with its lost spaces than the major cities, and this relationship is representative of many American experiences. Mount Prospect is a town that has a significant history, but unlike

New York or Boston, where there is a very strong cultural awareness of the area's past, many people in Mount Prospect have little awareness of local history. In addition, the books on larger cities tend to focus on famous buildings or buildings designed by famous architects. This book, however, is more oriented toward looking at the spaces ordinary people used and inhabited in their everyday lives.

This book will look at five categories of the history of lost Mount Prospect. The first is basically the idea of the town. Before the postwar expansion, the people of Mount Prospect had a different idea of what type of town they lived in. They considered it a small, independent community oriented around forms of production. The "Productive Past" will look at the farms and industry of an earlier time. People in the postwar community have tended to think of Mount Prospect as a residential community that is economically dependent upon the larger, metropolitan community. This is not to say that one way is better than the other, but that a basic sense of how the community is defined was lost. The second chapter covers interesting buildings that were built for businesses and have been demolished. The third section is about residential buildings and private spaces like gardens. Municipal buildings, schools, and churches that have been demolished make up the fourth chapter. The last chapter is about spaces that have been lost, although the buildings are still standing. There are a number of buildings in town that have been changed so radically that the original building is basically gone. This goes to show that sometimes things that are still there can be lost. The last few images are of buildings that were lost through neglect and unwise additions, but have since been found or their architectural integrity regained.

One
PRODUCTIVE PAST

Mount Prospect is older than the American idea of a suburb. While there were some country estates in Europe going back centuries, the idea of the middle-class residential community outside of a major city did not become common until the 1900s. The first suburban communities were in Long Island, New York, and along the streetcar lines outside of Boston. Areas outside of Chicago did not start developing suburban communities until the second decade of the 20th century. For the first 75 years of the history of Mount Prospect, there was no suburban development in the community and the village saw itself quite differently than it does today. For a long time, this was an agricultural community, and then over time, the community began to specialize in forms of agricultural production. There were huge greenhouses, creameries, and a number of onion sheds in Mount Prospect by the 1920s. The Mount Prospect of this time was working to become a center of production, not a residential community. This started to change in the 1920s, but it was not until after World War II that the community became the suburban community known today. The following chapter looks at what Mount Prospect was before it was a suburb.

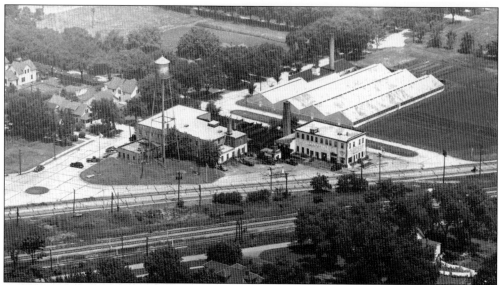

In this image, one can see part of Mount Prospect's productive past. Prior to the suburban developments that followed World War II, Mount Prospect was working to develop a mixed economy that included residential areas, commercial spaces, and light industrial development. In this picture are the Crowfoot Manufacturing Company building, where industrial staplers were made (built around 1925, demolished in 1986); the Mount Prospect Creamery building, at the time of this photograph it was used as the home of Braun Brothers Oil Company and later became home to Schimming Oil (built in 1910, demolished in 1986); and the greenhouses of Busse Flowers, which was one of a number of major flower producing enterprises (built in 1916, demolished in 1987).

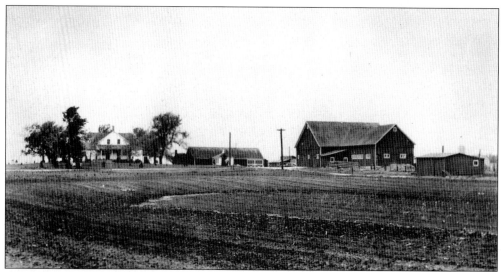

Most of Mount Prospect's past was as a farming community. It is no surprise that the early settlers to the area were farmers, but what is often overlooked is that Mount Prospect remained a mainly agricultural area through the first half of the 20th century. This photograph was taken in 1945 and shows the Fred Tonne farm. Built in the 1870s, and operating through the 1940s, the farm stood on Tonne Road in Elk Grove. The farm site was cleared to become the Berthold Nursery.

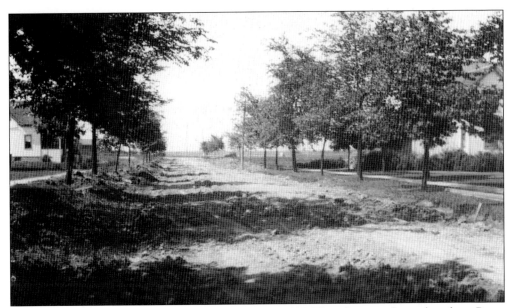

This picture shows the heart of Mount Prospect in 1927. The photograph is taken from Busse Avenue, looking north on Elm Street on June 5, 1927. While one can see the beginnings of the development of the town, one can also see how quickly the town became farmland. The dirt streets in this image were replaced later in 1927 with Mount Prospect's first paved roads, laid down by the Milburn brothers paving company, for whom Milburn Street is named. The house on the right is the parsonage of St. Paul Lutheran church.

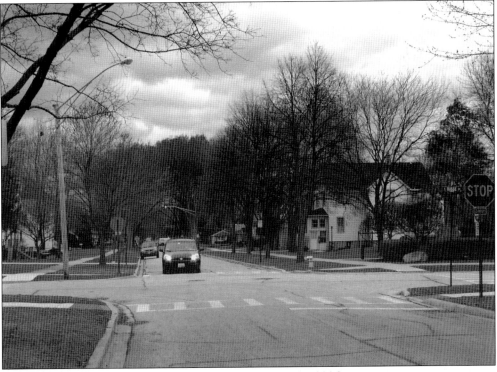

Here is a present-day view of Elm Street and Busse Avenue, 2006.

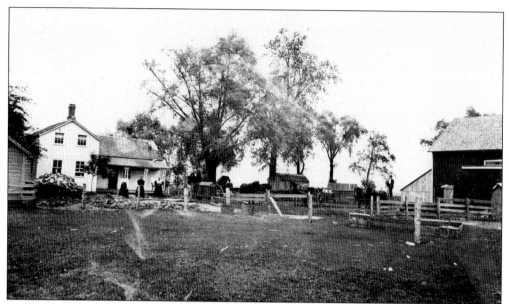

Mount Prospect's agricultural past goes back into the 1840s. This picture shows the John Conrad Moehling farm in about 1880. The 100-acre farm was between what is today Elmhurst Road, School Street, Council Trail, and Lonnquist Boulevard. John Conrad Moehling later leased his farm and purchased a general store at the intersection of Main Street and Northwest Highway in the small town of Mount Prospect. This became the Moehling general store and Mount Prospect's first post office. It is still standing today, although it has been moved to Pine Street.

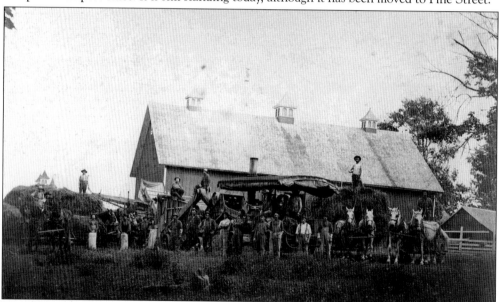

This photograph shows a lost time in Mount Prospect. The image is from around 1910 and shows the harvesting on a local farm. The image was donated by George Busse and shows the community efforts involved in a farming community. Members of many different families had to work together to bring in the harvest from each farm. Rather than a rugged individualism, this period in Mount Prospect's history was dictated by community-wide cooperation toward common goals.

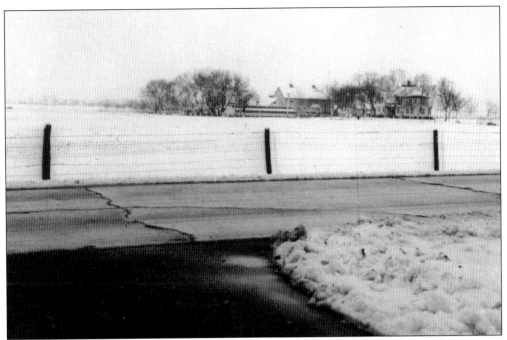

This image shows the Piepenbrink farm in the winter of 1947. Throughout World War II, Mount Prospect and many of the other suburban communities were important producers of food and agricultural products for the war effort.

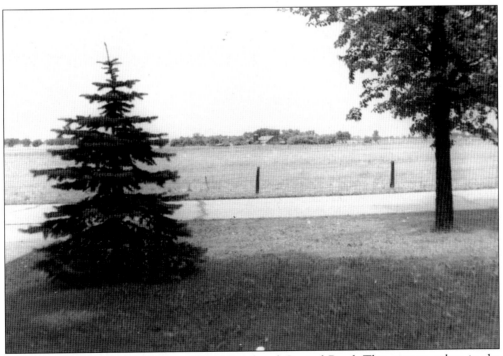

The Piepenbrink farm was close to Rand Road and Central Road. This picture, taken in the spring, was taken looking north from Central Road.

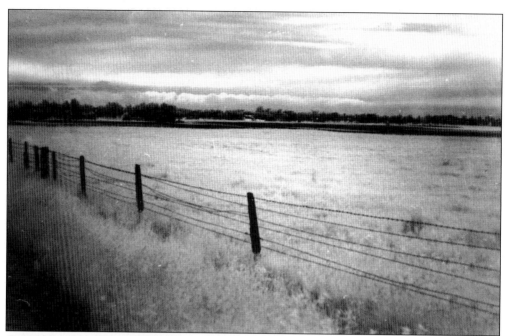

Central Road looked a lot different in 1947 than it does today. The community was dominated by farms rather than houses, and commercial development was centered in the downtown of Mount Prospect.

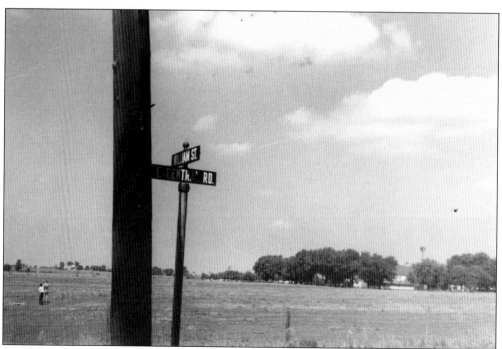

The intersection of Central Road and William Street was still very rural at this time. It is interesting to see that there is a telephone pole next to the road signs, so the area was certainly beginning to develop. The buildings in the distance are the Piepenbrink farm.

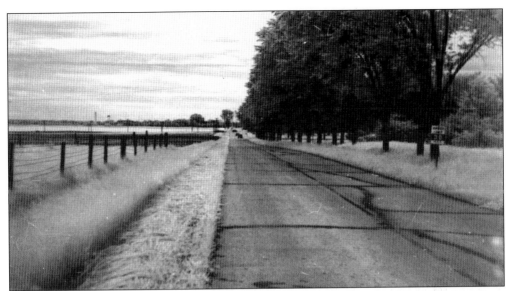

The development in the community at this time was mainly focused on developing the downtown area, and the area outside of the downtown was still mostly farms. There were few housing developments and little or no commercial development outside of the center of the village. The chimney and water tower that can be seen in the far distance are the Maryville Academy, when that was still an orphanage and school in a rural setting.

These three images are taken from the same location and the same angles as the preceding photographs, but are 60 years later.

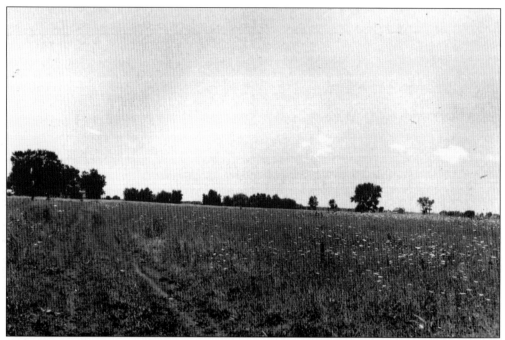

These three pictures show Highland Avenue, from Route 83, in July 1954.

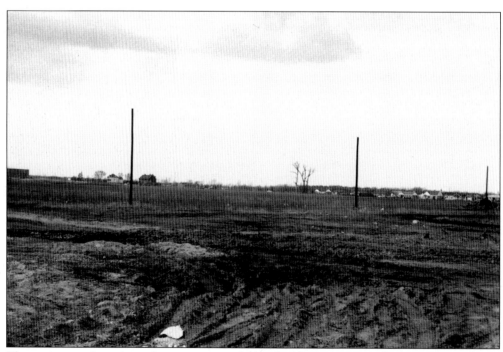

These pictures show the wide open spaces of what had been prairies, which were turned into farms and later tracts of housing.

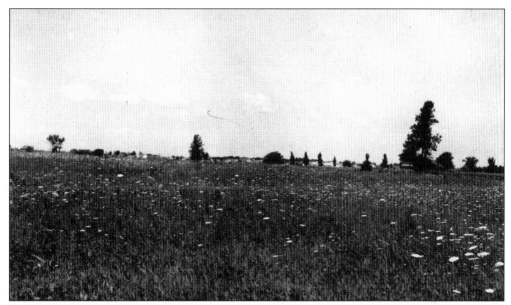

Four years after these three pictures were taken, construction began on Randhurst Shopping Center and Mount Prospect Plaza. Both of these developments were pioneers in their fields. Randhurst was one of the first, and at the time of its opening the largest, shopping malls in America, while Mount Prospect Plaza was one of the earliest strip shopping centers in the country. These types of developments shifted commercial development away from town centers toward the periphery of the community. This would be the end of the open spaces and farms.

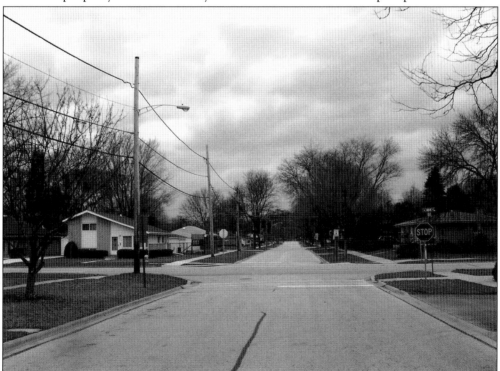

This is Highland Avenue as it looks in the present day, facing west, in 2006.

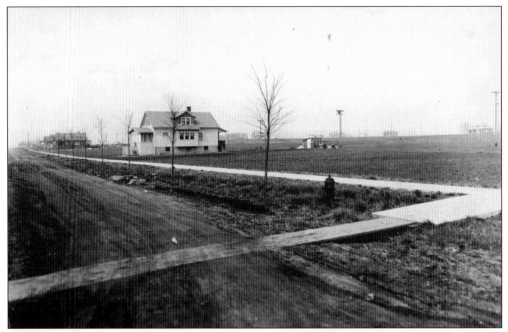

This image is a promotional photograph made for the real estate development called Busse's Eastern Addition, which was the first large subdivision added to Mount Prospect. It is interesting because it shows how undeveloped the area was during the early suburban development.

Almost 10 years after the end of World War II, much of Mount Prospect was still farmland. This photograph shows the intersection of Rand Road and Central Road in July 1954.

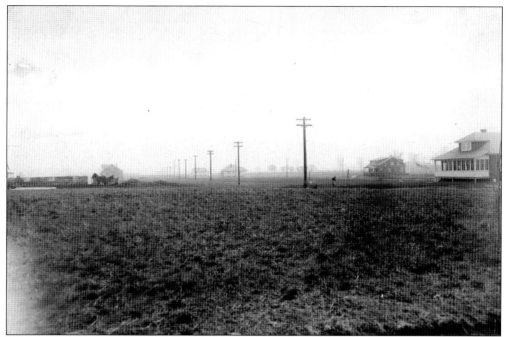

This image shows Edward Street and Busse Avenue looking southwest around 1926. This is also a promotional image for Busse's Eastern Addition.

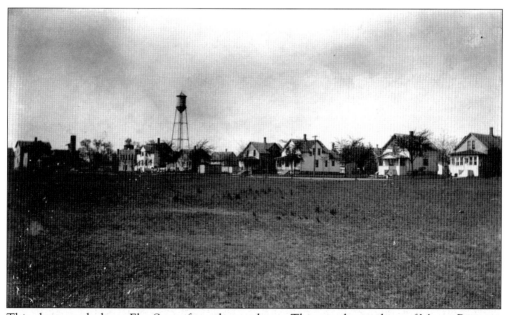

This photograph shows Elm Street from the northeast. This was the outskirts of Mount Prospect when this picture was taken. One can see the open space that made up much of Mount Prospect, as well as a couple of the early industrial developments in the distance. To the left of the water tower there is a two-story brick building that was built for the Mount Prospect Creamery, and a little further to the left are the buildings of Crowfoot Manufacturing.

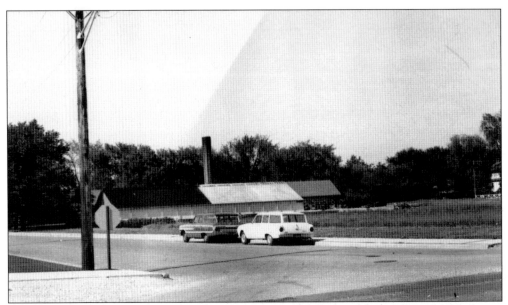

Mount Prospect was home to a number of major greenhouses. This was an interesting industrial development in the history of the community in the early 20th century. As Mount Prospect transformed from a farming community to a small town, one of the main commercial developments was industrial cultivation through greenhouses. This picture shows Haberkamp Flowers, located at 15 North Elmhurst Road (Elmhurst Road and Central Road). Haberkamp Flowers was founded around 1912. The site is now the Mount Prospect post office.

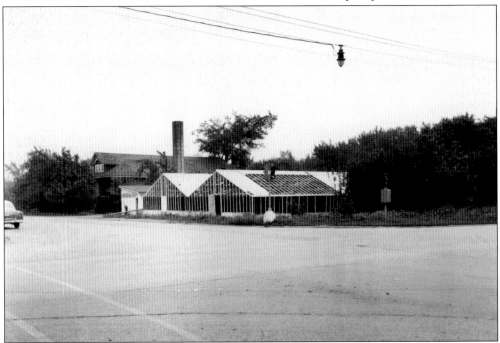

Another of the big flower producers was the Homeyer Greenhouses, located at the northwest corner of Central Road and Main Street. These greenhouses were built in the late 1920s. The site is now a strip mall.

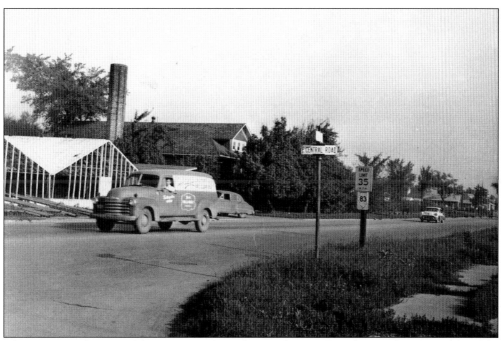

This is a second image of the Homeyer Greenhouses showing Main Street from Central Road.

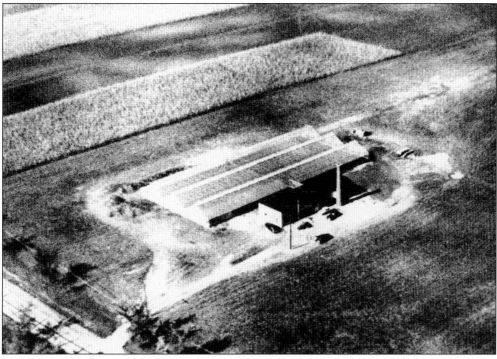

This promotional image shows the Kellen Brothers Greenhouses, which were located along Golf Road in Mount Prospect.

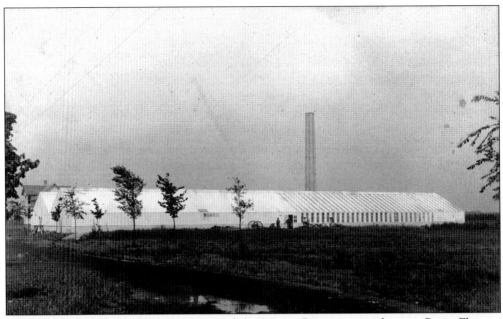

This photograph shows the best known of the Mount Prospect greenhouses, Busse Flowers. This is one of two of the Mount Prospect greenhouses that are still operating in the community, although the Busse's greenhouses were demolished in 1986 and Busse Flowers became a strictly retail establishment. This photograph is dated 1916, the year Busse Flowers was founded.

Behind Bill and Lizzie Wille one can see the open space that still dominated much of Mount Prospect in the 1940s, as well as the Busse greenhouses.

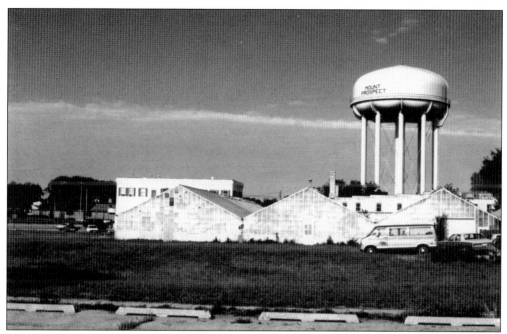

This photograph shows the Busse greenhouses shortly before they were demolished in 1986. At this time they were one of the last remnants of Mount Prospect's agricultural past.

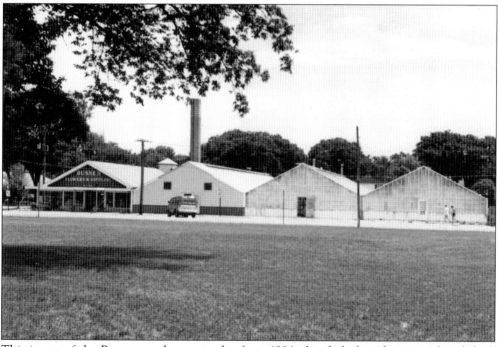

This image of the Busse greenhouses is also from 1986, shortly before they were demolished. The property was redeveloped as part of a tax increment financing district and was turned into townhouses.

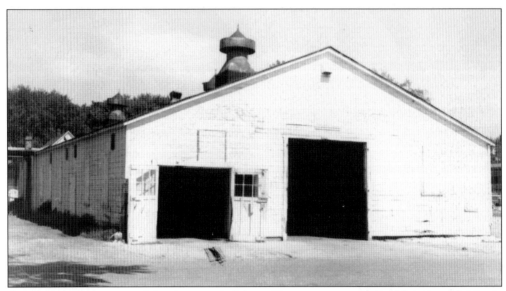

Another major commercial development in Mount Prospect was specialized farming. The farms left in the area picked one or two crops that grew well in the area and focused on these. One of the crops that did well in the area was onions and so a number of specialized services for the farmers also developed. This picture shows an onion shed that was used to store the onions before they were shipped out, which allowed the farmers to hold their onions until the prices rose and they could get a better price. This onion shed was built in 1916 and stood at 5 South Pine Street.

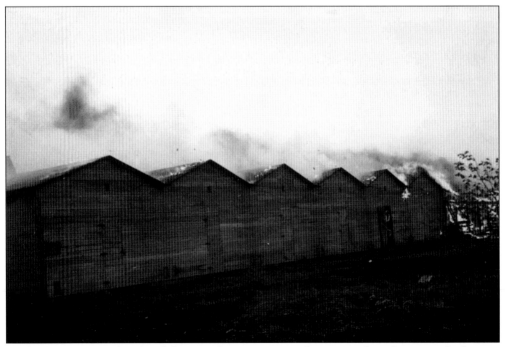

As the farms were replaced with houses, the supporting industries, such as the onion sheds, were no longer viable. Over time, the sheds were demolished or burned, as in this picture, to make the real estate available for other developments.

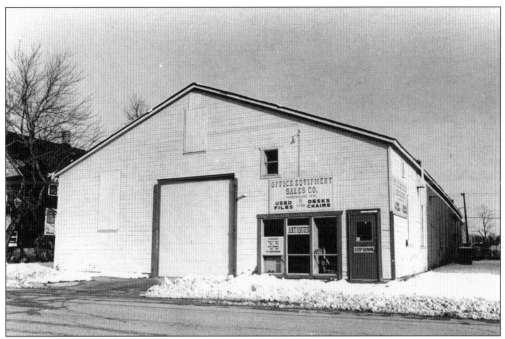

The onion sheds that were not demolished were adapted for other uses. This picture shows the onion shed on Pine Street that was adapted and used as a warehouse for an office equipment dealer. The building has since been demolished.

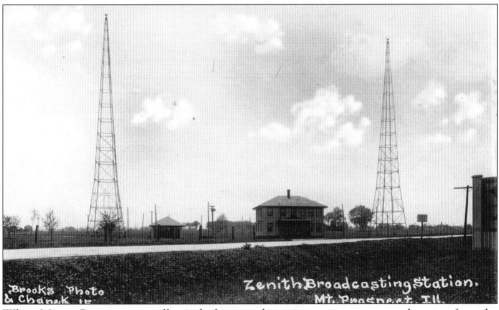

When Mount Prospect was still mostly farms and open space, it was a great location for radio broadcasting. For close to 50 years, Mount Prospect was home to a pair of radio towers and an early broadcasting station. The Zenith towers operated from 1924 through the 1970s. Zenith built the towers in Mount Prospect to broadcast into Chicago and to all the farms and small towns northwest of the city.

There was a small broadcasting station between the towers that was also the home of the Zenith employee who ran the station. He and his family can be seen in this picture from around 1930. Gilbert Gustafson was the first station manager for WJAZ. He lived in the station with his family from around 1925 through 1935.

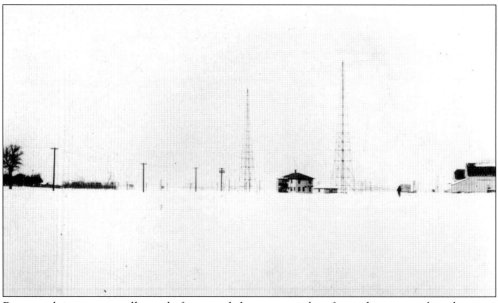

Because this area was still mostly farms and there were only a few radio stations broadcasting, there was little interference and on a clear day one could pick up radio stations from hundreds of miles away. Unfortunately, because the radio signals were much weaker, on a day with wind, rain, or clouds one could only pick up the most local stations. As can be seen in this image from around 1940, these Zenith station towers were the tallest things in Mount Prospect and could be seen for miles.

In the 1920s, radio was in its infancy and while this location allowed WJAZ to broadcast to a huge area, the new technology and the isolated location meant the staff had to be on call. This c. 1928 picture shows Gilbert Gustafson, the first station manager who lived in the station. While the Gustafsons had to live in relative isolation, the good side was that much of early broadcast radio was done live and this meant that many bands would come out to the station from Chicago and around the country to play. Some of the most famous musicians from the big-band era played in Mount Prospect and in the Gustafson's house.

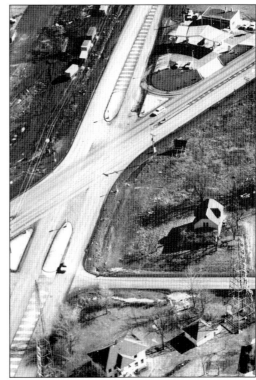

This aerial photograph shows how the area developed since the early images of the station. The station and tower can be seen at the bottom of the photograph at the intersection of Rand Road and Central Road. One can also see the construction of the Mount Prospect Plaza in this c. 1960 photograph.

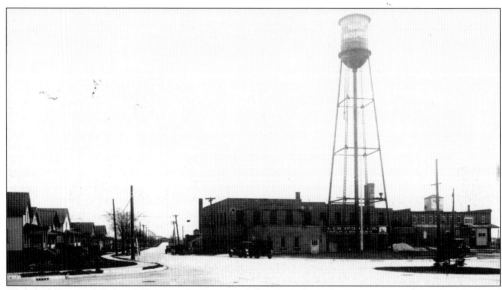

The building just behind the water tower was the Crowfoot Manufacturing Company around 1925. This company was probably the largest industrial concern in Mount Prospect in the 1920s. Originally started in 1905 in the Crowfoot family home in Milwaukee, Wisconsin, it moved to Chicago to take advantage of the larger market and the easy access to transportation. The firm moved to Arlington Heights in the early 1920s but was lured to Mount Prospect by William Busse a few years later. The factory was located along Northwest Highway between Maple Street and Evergreen Avenue.

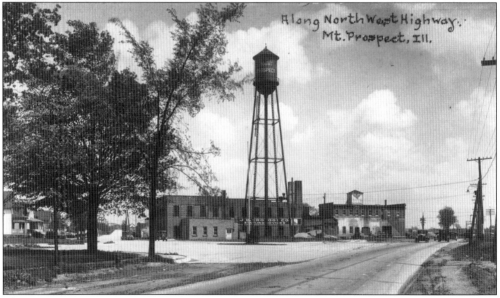

The Crowfoot factory produced "modern and up-to-date" staplers and tackers for a number of uses, including assembling screens and attaching labels to shipping crates. When Crowfoot moved to Mount Prospect, they brought a workforce that greatly increased the population of the community and improved home sales in the Busse Eastern Addition. The houses on the left side of this photograph are a part of the Busse Eastern Addition, while the brick building to the right was originally built by the Mount Prospect Creamery.

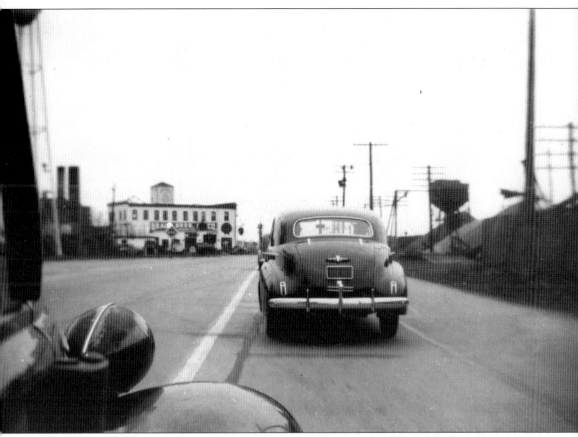

This 1939 view of Northwest Highway shows some of the industrial development in Mount Prospect. In the distance one can see the Braun Brothers Oil Company; the building was originally built for the Mount Prospect Creamery but later adapted for Braun and then Schimming oil. This stood directly next to the Crowfoot Factory.

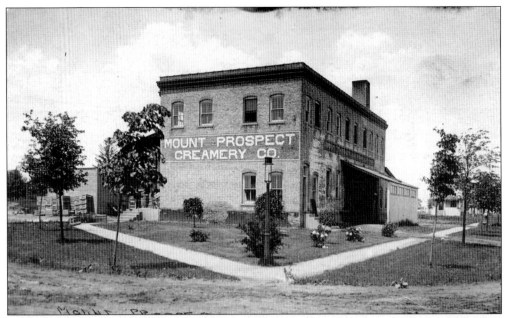

The Mount Prospect Creamery was founded in 1910 by Edward Busse. Seen here in 1921, it had quickly become a major distributor of milk, cheese, and butter as Mount Prospect became one of the largest producers of dairy products in northern Illinois and the Chicago area in the early 20th century. They employed 13 drivers who delivered the bottled milk, advertised as "Milk Bottled in the Country," around the northwestern communities and into Chicago.

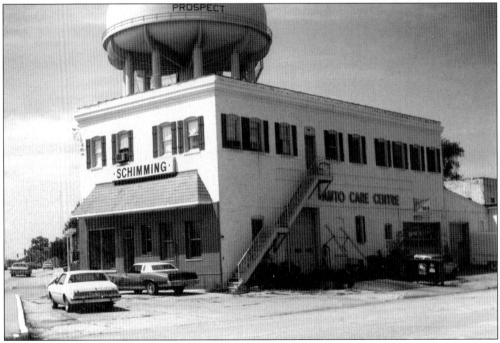

Over the years, the Mount Prospect Creamery building deteriorated and much of the original architectural character of it was obscured. It became first the Braun Brothers Oil Company and then Schimming Oil and Auto Care. This photograph is from 1982.

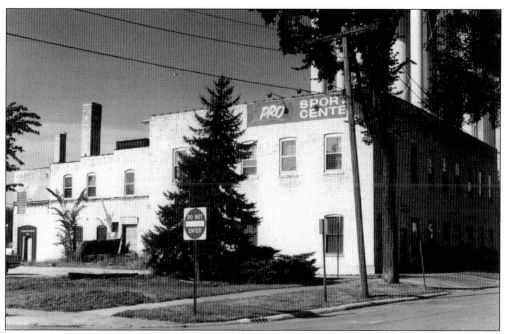

The Crowfoot factory was also allowed to deteriorate and was put to a number of different uses. By the 1980s, it was used as the home of the Pro Sports Center.

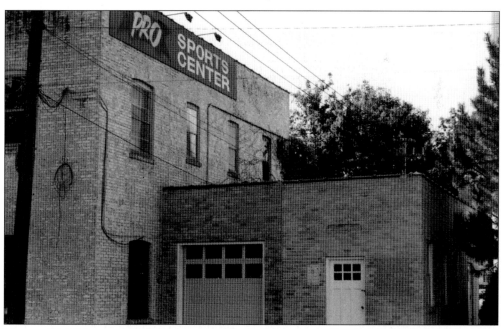

The small addition to the building that can be seen here was used by the village of Mount Prospect to house the early equipment of the fire department and part of the village's government and water supply. In 1977, the historical society took over the small addition and opened a municipal museum; however, this was a relatively short-lived project. By the early 1980s, the building had been taken over by the Pro Sports Center and much of the building's past was overshadowed by its commercial use.

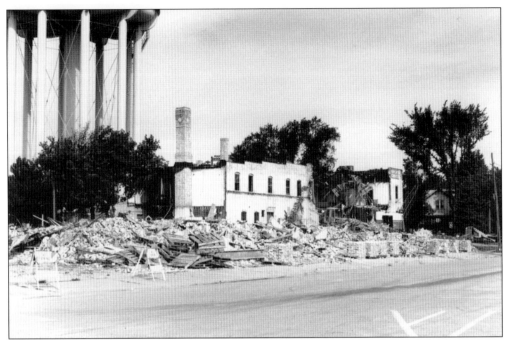

The Crowfoot building and the Mount Prospect Creamery building were demolished in 1986 as the first development in the Mount Prospect Tax Increment Financing District. The buildings were replaced by townhouses.

With the demolition of Crowfoot, Mount Prospect Creamery, and the Busse greenhouse buildings in 1986, Mount Prospect removed the last buildings that represented its productive past. Once community leaders had spent much of their energy trying to attract factories and encourage agricultural and industrial production, but following the post–World War II development of the suburbs, the buildings were seen as eyesores rather than an economic foundation for the community.

Two
LOST BUSINESSES

Some businesses become institutions in their community and some businesses construct buildings that become icons of community identity. However, businesses change over time and with changing uses some buildings lose their character. Some of the most identifiable buildings in Mount Prospect have been altered and have lost their distinctive character. With their loss of character, these buildings have been seen as blighted or simply as having outlasted their usefulness, and have been demolished. This chapter looks at some of these businesses and some of the buildings and what happened to them.

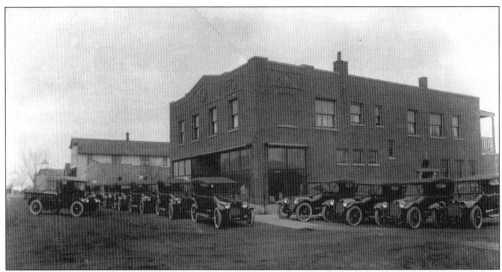

This photograph shows the heart of Mount Prospect's business district in the early 20th century—Busse Avenue around 1916. The building in the foreground was William Busse's store and the first home of Busse Buick. This building was constructed in 1912 and has also been home to the Mount Prospect State Bank, Danneo's Ice Cream, and a number of restaurants. The small cinder block building to the side was built in 1915 and used as the first garage for Busse Buick. It was demolished in 1927. Past the cinder block building is Wille's Tavern, which was built in 1905 and is still standing today. Past that is Wille's Hall, a small meeting place for the community, where many of the early decisions of the community were made. Wille's Hall was demolished in the late 1920s.

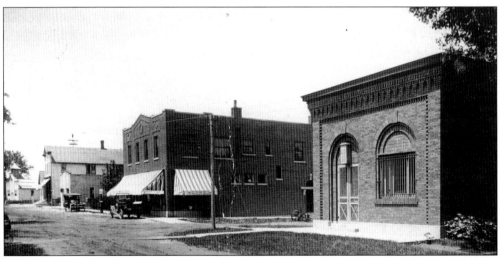

Here is a view of Busse Avenue and Main Street, looking west, around 1916. The small brick building in the foreground was the original home of the Mount Prospect State Bank (originally incorporated as Mount Prospect National Bank). This view shows a big part of the Busse and Wille families' businesses in Mount Prospect. The first three buildings housed businesses started by William Busse—the bank, William Busse's store, and the cinder block garage for Busse Buick. Just past the William Busse buildings are Wille's Tavern, the first barber shop in Mount Prospect, and Wille Hall, both built by William Wille and run by the Wille family.

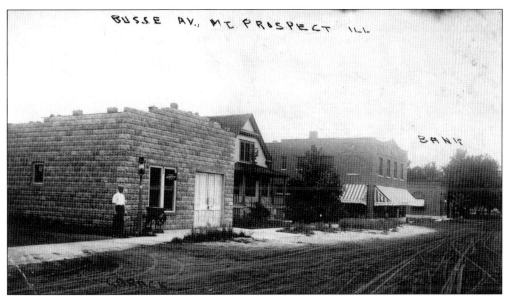

Here is Busse Avenue, looking east, around 1916. The small cinder block building in the forefront was built as the garage for Busse Buick in 1915 and demolished in 1927. The house is unidentified, but it was moved, prior to 1927, to Main Street and was gone by the early 1950s. The large brick building on the corner was built as the home of William Busse's store and was still standing in this location 90 years later. The small brick building, built in 1911, was the first home of the Mount Prospect State Bank, until 1928. It was then used by the public library and a sandwich shop before being demolished in the 1960s to build a parking lot. It is now the walkway leading to the back of the Mount Prospect Village Hall.

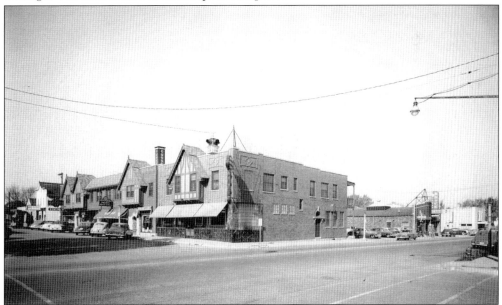

This intersection changed over the years. On Main Street, one can see Busse Buick and past it the Prospect Theater, as they appeared in around 1954, both have since been demolished. This stretch of Busse Avenue looks much as it did at the beginning of 2006, the one exception being that the Wille Lumber building can be seen in the far left corner.

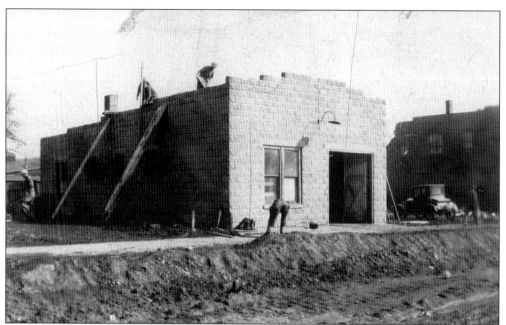

Unfortunately this photograph has been damaged, but it shows the demolition of the Busse Buick garage on March 9, 1927. The garage and the small house, seen earlier, were replaced by the large Busse building in 1927. This building has the famous Busse chimney, which has helped to define downtown Mount Prospect for the past 80 years.

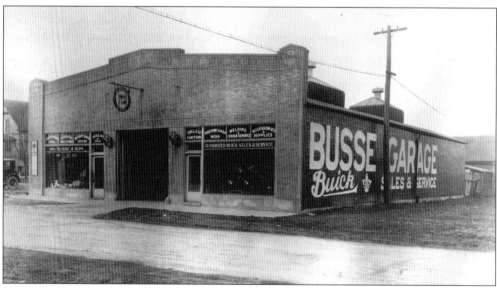

In 1908, William Busse bought a new car he noticed while walking by a Chicago Buick dealership. He was so impressed that he contacted the manufacturer and offered to become a local agent. Two years later, he was visited by a Buick representative who had come to offer Busse a charter for a local agency. Busse Buick was born in 1912 and was originally housed in the building at 2 West Busse Avenue. Later the small cinder block garage was built, and in 1918, this building was constructed, although it was added to in 1921 and 1928. Just past the garage is the house that was seen on Busse Avenue around 1921.

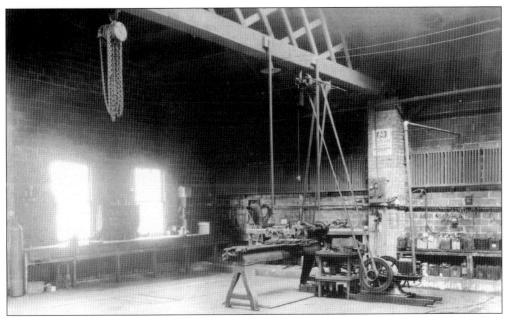

Originally the dealership was run from the building at 2 West Busse Avenue, and each day they would roll the cars out onto the street in the morning and then roll them back into the store at night. The 1915 cinder block building was built to be used as a service station, complete with gas pumps; however, it was still too small for their operation. In 1918, they began construction on this building at 30 South Main Street. The building was expanded in 1921 and then again in 1928. Here is an interior view dating from 1922.

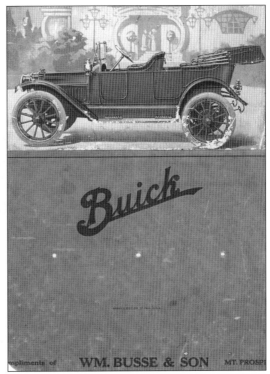

This was an early advertisement for Busse Buick and one of the early models of the Buick company from around 1917.

While William Busse may have had a hard time getting started with his Buick dealership, he was certainly able to stay in business. The Busse Buick dealership remained a landmark in downtown Mount Prospect for 50 years and remained within the Busse family for the entire time. When the dealership was sold in 1966, it was the oldest Buick dealership in Cook County. It was sold to John Mufich and the name was changed, although he maintained the location for a number of years.

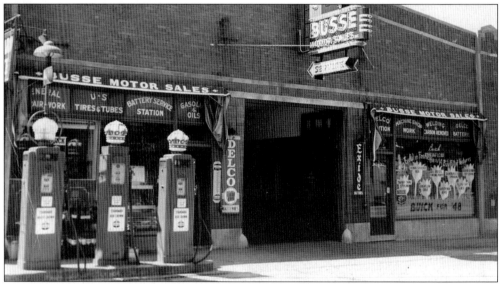

The building along Main Street was a center in the village. It was a full-service mechanics shop, gas station, and a car dealership, as seen here around 1948. However, with the development of larger dealerships in fringe areas and increased sprawl, this dealership was not large enough to compete and had no space to grow. The dealership eventually moved, and the building was later used by the Northwest Electric Supply Company. The facade was modified, and the structure was not well maintained. The building was demolished in the 1990s to make way for a condominium building.

Here is Busse Avenue, looking east across Main Street, in 1912. The building to the left is 2 West Busse Avenue when it was used as William Busse's store, and just past it is the original Mount Prospect State Bank building that was later demolished in the early 1960s. To the right one can see the Richard Busse house that was demolished in 1966.

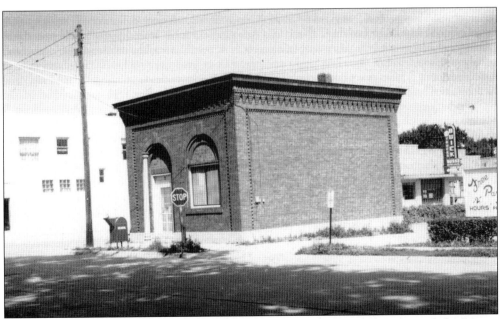

This small building housed the state bank from 1911 to 1928 and then housed the Mount Prospect Public Library from 1932 to 1944. In the background of this 1955 photograph one can see Busse Buick and Main Street. It appears that the building is empty in this picture, although it would later become home to Golden's Delicatessen and Food Stop. The building was demolished in the early 1960s.

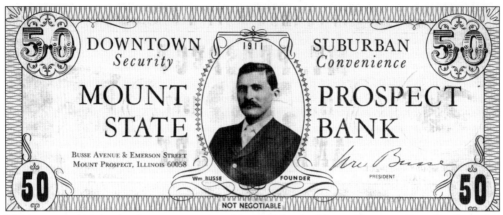

This commemorative bank note was printed in 1967 by the Mount Prospect State Bank on the occasion of the 50th anniversary of the incorporation of the Village of Mount Prospect. William Busse's face is on the bill.

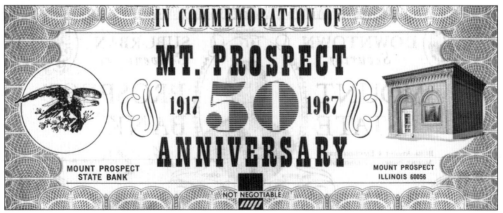

The back of the commemorative anniversary note shows the original bank building, which had been demolished by the time this was printed. The Mount Prospect State Bank later merged with First Chicago Bank, which merged with Bank One, which merged with Chase Bank.

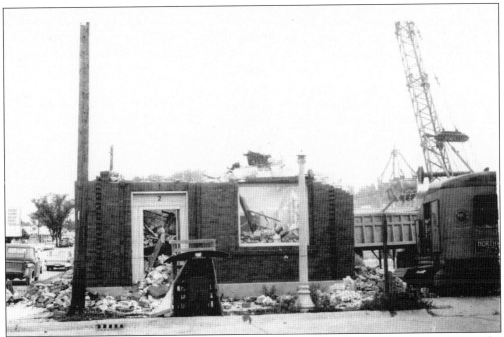

This is the demolition of the Mount Prospect State Bank building in the early 1960s. The view is from Busse Avenue and Main Street, looking north. To the side one can faintly see the Prospect Theater sign.

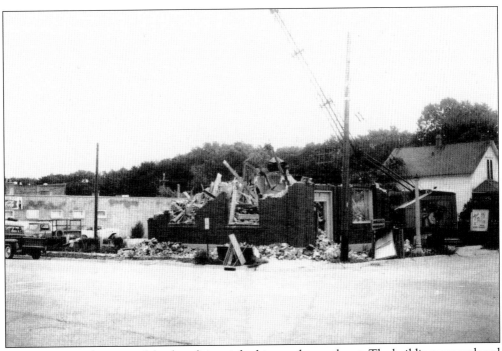

This image, another view of the demolition, is looking to the northeast. The building was replaced with a parking lot. Nothing has ever been built on the footprint where the building stood.

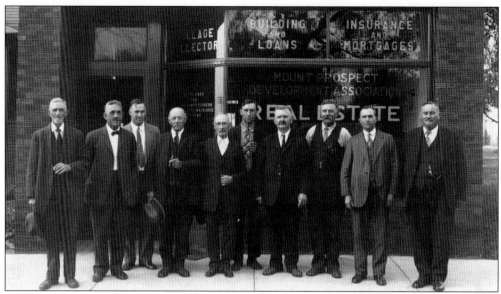

The Mount Prospect Development Association was formed in 1923 to help Mount Prospect expand in the boom years of the 1920s. The development association's original building stood at 12 East Busse Avenue. It is seen here around 1925. The organization was responsible for the first of many subdivisions that were added to Mount Prospect, the Busse Eastern Addition, which included the platting and subdividing of the area bounded by Northwest Highway, School Street, Central Road, and Mount Prospect Road. The man in the light-colored suit, second from the right, is George Busse, the main force behind the Mount Prospect Development Association.

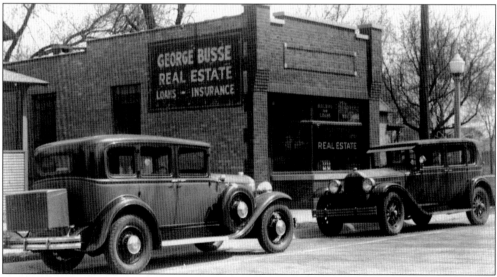

The Mount Prospect Development Association was renamed George Busse Realty in 1937. This photograph is of the same building as the previous image. The building stood at 12 East Busse Avenue. This small building was home to the realty company for many years before it moved to 330 East Northwest Highway. The building continued to be used by a number of different businesses. Most recently it was used as a doctor's office until it was demolished in 2004.

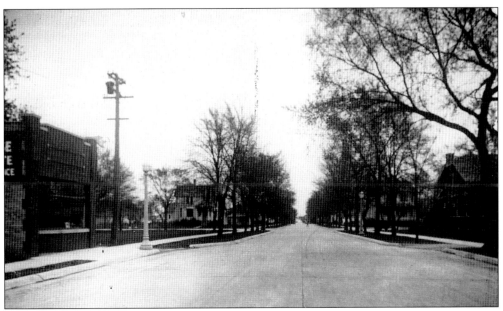

Here is Busse Avenue, looking east, in 1938. The cross street that can be seen is Emerson Street, and on the left-hand side is George Busse Realty. This image is undated, but based on the name of the realty company, the paved streets, the phone lines, and the electric lights, it must be around 1938. The house on the right was William Busse's second house. It was built in 1919 and moved to Central Road in 1958. Past William Busse's house one can see the Richard Busse house that was demolished in 1966.

With time, the George Busse Realty company needed to expand. They expanded the small structure and continued to use the building into the 1950s. The building one can see to the right was the first building designed as a public library in Mount Prospect. It was dedicated in 1950 and expanded significantly in 1961. Seen here around 1955, it was later used as the Mount Prospect Senior Center and was demolished in 2004.

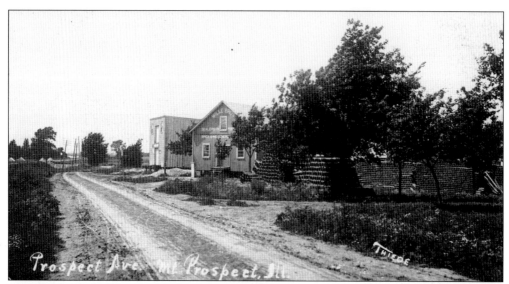

This 1900 picture shows a couple of interesting points. The two buildings in the picture are Wille Brothers Coal and Lumber. The Wille family was one of the founding families of Mount Prospect, and much of the village was built from supplies bought from the Wille brothers. Taken before the construction of Northwest Highway, this image identifies the road as Prospect Avenue. Northwest Highway was very important to the development of the community. Before it was built, there were many small roads that had been laid out by real estate speculators and none of them connected in any systematic way. This meant that getting to Chicago was a long and confusing trip that could involve getting very lost. The new highway vastly improved development and real estate value in Mount Prospect.

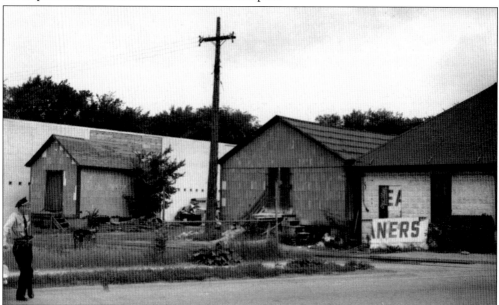

The Wille brothers may have supplied much of the building materials for the community, but their own buildings deteriorated. This photograph was taken during the demolition of the Wille Brothers Coal and Lumber buildings in 1959. The police officer observing the scene is George Whittenberg, longtime police chief.

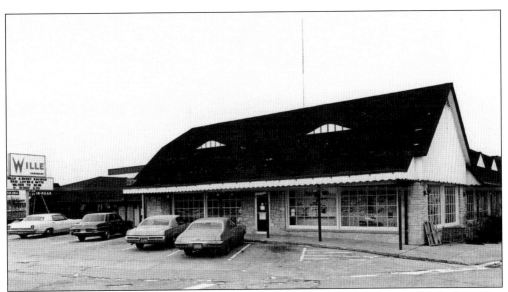

This building, seen around 1975, replaced the original Wille Brothers Coal and Lumber buildings. The store was modified to be a hardware store and survived in the community for many years. The Wille family once controlled a big block of land along Busse Avenue and Northwest Highway. Wille Tavern started the line and was followed by the first barber shop, started by Adolph Wille, which was followed by Wille Hall and then the Wille Brothers Coal and Lumber buildings. Most of these buildings have been demolished, although Wille's Tavern is still standing. The Wille hardware store was demolished in the early 1980s.

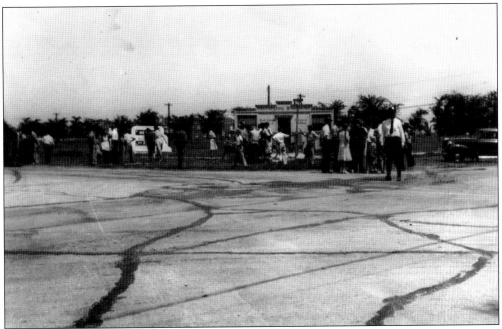

This is a photograph from the Mount Prospect Police Department recording a traffic accident, which shows Central Road and Main Street in 1940. The small building was a real estate office, although it is hard to make out the name of the company. The building is long gone, as is the company.

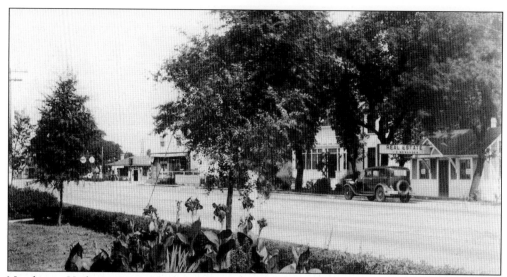

Northwest Highway is seen between Emerson and Main Streets around 1930. The building with the car in front of it was the real estate office of I. E. Besander, the third mayor of Mount Prospect. He was elected in 1937 and served throughout World War II. His office was demolished by 1950. Next door to the real estate office (set back) was John Conrad Moehling's house, built in 1890 and demolished in 1966. Past the Moehling house is the Moehling general store, which was moved to Pine Street in 1999. The building past the general store was built as a service station for John P. Moehling, and although it has been radically modified, it is still standing at this location and is now a sandwich shop.

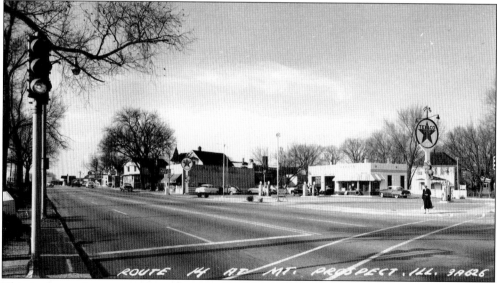

This is almost the same angle as the previous image, 20 years later. A number of the buildings in the last photograph can also be seen in this image, although there have been some changes. I. E. Besander's office has been replaced by Keefer's pharmacy and the Moehling service station cannot be seen, but one can see the John Conrad Moehling home and the Moehling general store. In this picture one can also see William Busse's first home in its second location on the far right. It was moved from the intersection of Busse Avenue and Main Street to this location around 1930, and then in 1958 was moved to 808 East Central Road.

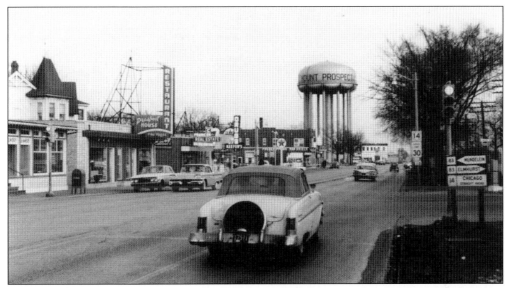

This picture is of the same block as the last two, although it is looking in the other direction and it dates from 1961—30 years after the first image and 10 years after the second. The area has changed significantly over the years. One cannot see the Moehling general store, but can see the John Conrad Moehling house; however, two buildings have been constructed in front of it. One is being used as the Prospect House Restaurant, while the other building is the C. Francek Real Estate office. The Franceks were the descendants of John Conrad Moehling. Beyond the real estate office are Keefer's and Van Driel's pharmacies.

Here is Keefer's pharmacy around 1955. Jack Keefer was a World War II veteran who served for four years on the crew of a PT Boat. After the war he and his wife moved to Highland Park and he worked in a pharmacy in Glencoe until 1949, when he purchased a pharmacy in Mount Prospect from a man named Steve Brant, who had purchased the pharmacy from George Engblom, who had started a pharmacy in a smaller building. Keefer soon became a fixture in the community and worked out of this location until 1966, when he moved to the other side of the railroad tracks.

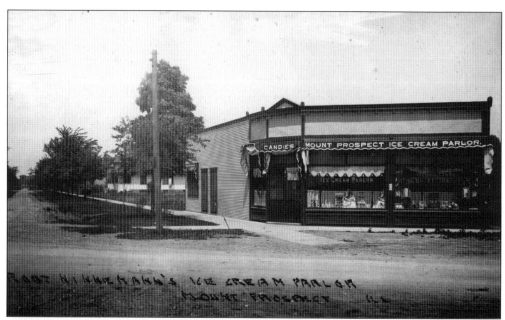

The Robert Ninnemann's Ice Cream Parlor is pictured here around 1920. This building stood at the corner of Emerson Street and Northwest Highway and was built by the Moehling family some time around 1915. It was later sold to the Busse family, who replaced it with the E. Busse building on the site.

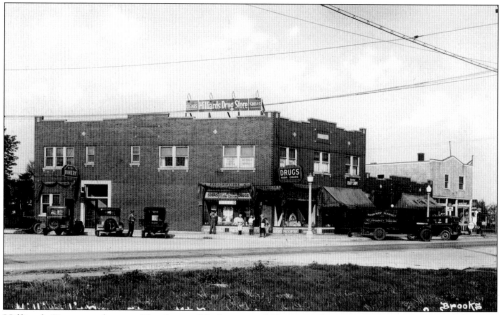

Hilliards Drug, see here at Northwest Highway and Emerson Street in 1930, was one of the first pharmacies in Mount Prospect. It was housed in the E. Busse building, which was built in 1927 and is still standing. The white building to the right was the home of Oakland Pontiac and there is little known about it. It was standing in 1926 before the E. Busse building and was later home to a clothing store. It was demolished by the end of the 1960s.

Behind these two members of the Kruse family on Prospect Avenue, one can see across the tracks to Northwest Highway and the two-story frame building from the previous photograph.

This interesting photograph looks across Northwest Highway, the commuter parking lot, and the railroad tracks at Prospect Avenue in 1953. The building to the right is Kruse's Tavern, today known as Mrs. P and Me's. However, the building in the center is unknown. It looks very similar to Wille's Tavern, but is in the wrong location. It may have been a part of Kruse's.

This photograph was taken from the lawn outside the back of the Central Standard School on Main Street in 1953. The Prospect Theater is the most prominent thing in the photograph and was once a center in the community. The Prospect Theater was a classic one-screen theater with a location to which hundreds of families could walk. However, with increased developments along the periphery of towns, the one-screen theaters had a hard time competing with much larger theaters that were located outside of town, but had more parking.

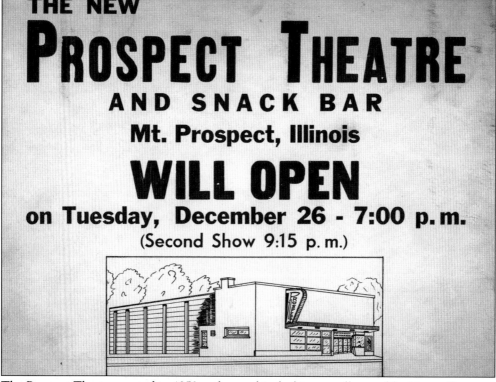

The Prospect Theater opened in 1950 and was a big deal in a small town like Mount Prospect. This was the first real theater to open in the community and it was a sign of the community's independence. It opened the day after Christmas, and the first two movies to be advertised on the marquee were *Tea For Two*, starring Doris Day and Gordon MacRae, and *Copper Canyon*, starring Ray Milland and Hedy Lemarr.

This playbill for the Prospect Theater was issued in 1951, during the heyday of downtown theaters. Before the development of huge multiplex theaters on the outskirts of towns, the downtown theater was a mainstay of local entertainment and social life. This playbill features the movie *I Was a Communist for the FBI*, a film that shows a glimpse of America during the Cold War, starring Frank Lovejoy.

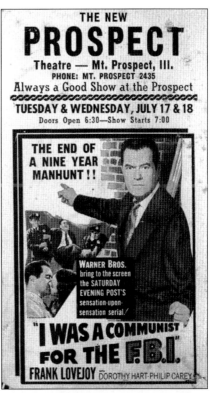

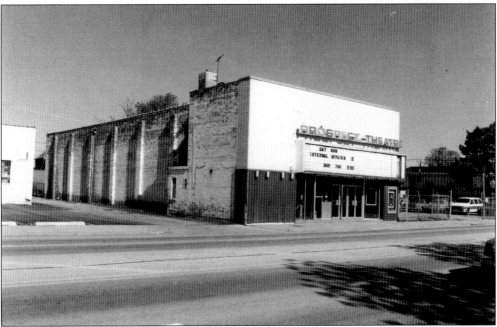

Over the years, the Prospect Theater was surpassed by the larger theaters in the area and was not maintained. The distinctive marquee and awning were taken down when Route 83 was widened, and by 1990, when this picture was taken, the theater did not look like a center for local community life, although it was still popular for showing *The Rocky Horror Picture Show*.

This c. 1980 photograph, taken from the public library, shows the Prospect Theater in its later stages and the building that had been the Busse Buick dealership. The photograph shows the Northwest Electrical Supply shop that replaced the old Buick dealership. Both the theater and the light fixture store were demolished to build condominiums.

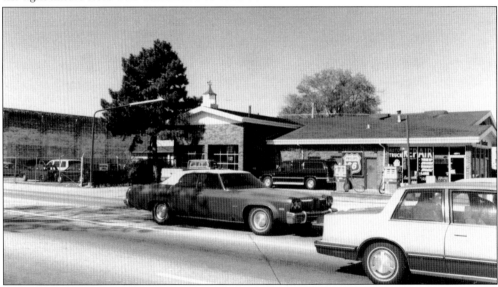

Norb Huecker's Service Station stood on the corner of Main Street and Central Road for more than 80 years. The business was started by Richard Huecker, Norb's father, in 1917, and is seen here in the mid-1980s. When the gas station opened, there were still many horse and buggies on the roads. Huecker was famous for having long-term clients and offering very personal service. He was known to drive people's cars back to their houses after he was finished servicing them, leave the car in the driveway, and walk back to the service station. The building was purchased by the Village of Mount Prospect in 1999 and demolished to make way for condominiums.

This is the inaugural program for the Mount Prospect Cinema on Rand Road near Central Road. The cinema opened on November 1, 1963, with the film *The Thrill of it All*, starring Doris Day and James Garner. While the program claimed that the theater had a "giant architecturally framed screen [that] is the largest ever installed in a theater in the Midwest" and the program had a welcome note from the Mount Prospect mayor C. O. Schlaver, there is very little known about the business. There do not appear to be any photographs of it, and it is not clear how long it was in business.

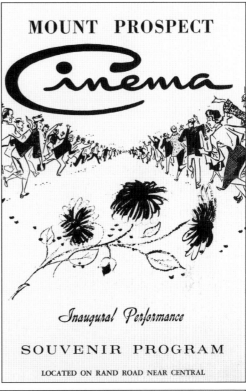

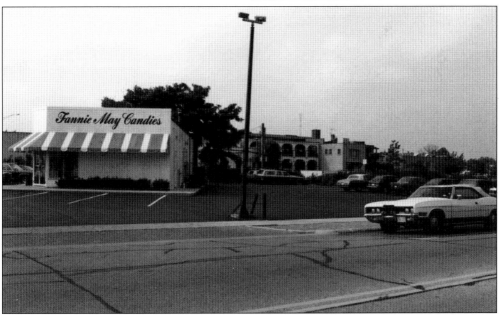

Fannie May Candies stood at the intersection of Northwest Highway and Emerson Street for years. The building was originally built as a Texaco station, which can be seen in some of the earlier photographs of Northwest Highway. Fannie May Candies eventually moved across the railroad tracks to a new building at the intersection of Main Street and Prospect Road. This building was demolished in 1999 for the construction of condominiums.

This is a series of four photographs that make up a panoramic view from Henry Street and Kenilworth Avenue. On the back of the pictures "from Henry and Kenilworth looking west to where Bruning now is, 1954" is written.

This is a c. 1960 picture of the plant that replaced the farms seen in the preceding image. On the back of this image is written, "The glassed in, beautifully-landscaped area is a real innovation in plant design. It is adjacent to the cafeteria, and offers a brief noon-hour respite of sun and relaxation." The Bruning Company merged with Addressograph Multigraph Corporation, which still operated in the community into the early 1990s under the name AM International. The plant was located at 1800 West Central Road.

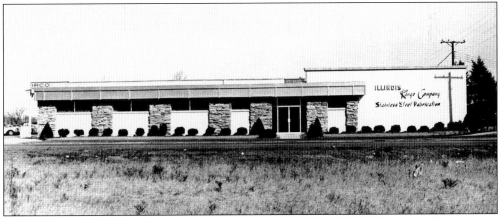

The Illinois Range Company was another major producer in Mount Prospect. The company began making range tops in the early 1920s, although it shifted away from making ranges and began making a full line of stainless steel and sheet metal equipment for the food service industry. This included the early kitchens for McDonalds, including the first McDonalds in Des Plaines. Illinois Range moved to Mount Prospect in 1944 and expanded its facilities in 1964. It continued to operate out of this building, located at 708 West Central Road, through the late 1990s, when it moved one block down Central Road to 800 West Central Road. It ceased to operate in Mount Prospect in 2001, when it was sold to Franke Commercial Systems, a division of a Swiss conglomerate.

Bowling—Brewers' 49

GUNNELL'S BOWLING LANES

AMF AUTOMATIC PIN SPOTTERS

16 ALLEYS
AIR CONDITIONED
OPEN and LEAGUE BOWLING
• PARKING FACILITIES
• COCKTAIL LOUNGE
• RESTAURANT

We Cater To Banquets and Parties

CLearbrook 3-8171

WE DO NOT ACCEPT TELEPHONE RESERVATIONS

FOUNDRY and ELMHURST
MOUNT PROSPECT

Another business that has been hard to track down is Gunnell's Restaurant and Bowling Alley. This advertisement dates from 1956. Many people who lived in Mount Prospect before 1970 remember it fondly. According to some people's recollections, it was in business as far back as the early 1930s. The building was a two-story frame building with two large bay windows on the front. There was a bowling alley, as well as a restaurant in the building, and early in its history there were gas pumps outside. The building stood at the intersection of Rand Road and Main Street, close to Randhurst Shopping Center; however, there is not a single photograph of the building. This advertisement is from the 1956 phone book. The building was demolished in 1969, and a series of other businesses have been built on the site since then.

Three
Lost Houses

Many of the oldest houses in Mount Prospect have been demolished. Some of these houses were quite unique and were standing for generations in the community. However, over time, many of these houses lost their distinctive touches and were eventually demolished. Some of these houses had unfortunate additions put onto them or were converted into other uses. With these changes it became hard to see the value of the houses, and they were eventually seen as unwanted structures. Other houses had the decorative touches removed to simplify maintenance. These also lost their distinctive character and were demolished. Some were just demolished to make space for newer developments. This chapter looks at some of the houses in the community that have been lost.

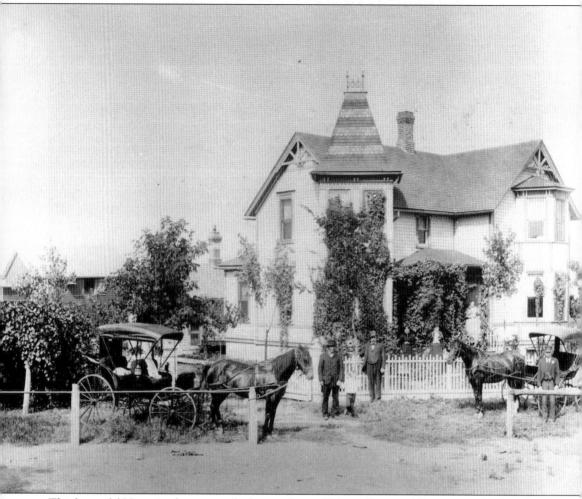

This beautiful Victorian house was the home of one of Mount Prospect's biggest promoters, John Conrad Moehling. He ran the first store in Mount Prospect and was responsible for opening the first post office; bringing John Meyn, the first blacksmith, to town; and transforming Mount Prospect from a wide spot in the road into a small town. John Conrad Moehling's house represented his importance to the community. The house, seen here around 1900, stood at 8 East Northwest Highway and was built around 1890.

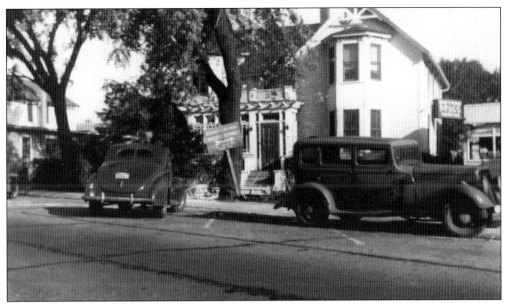

This is a second view of Moehling's stately home around 1942. John Conrad Moehling moved to Mount Prospect in 1882 and built this house a few years later. Notice that Northwest Highway has been widened and is now much closer to the front door. To the left of the house one can see the side of the Moehling general store and on the right is Steve Brant's pharmacy, the predecessor of Keefer's pharmacy. The house is still largely intact, but its neighborhood is beginning to become crowded.

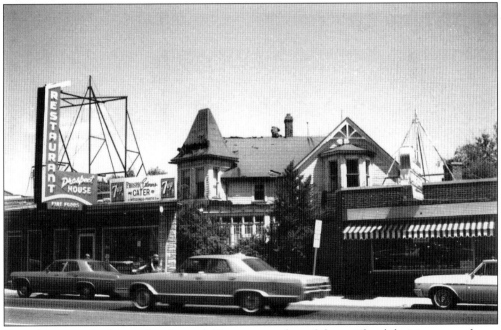

Over the years, the house deteriorated. Due to a number of short-sighted decisions, storefronts were built in front of the building and the house was allowed to decline. Once the finest house in town, home to the community's biggest promoter, and an actual Victorian house, the Moehling house became seen as an eyesore and was demolished in 1966.

The Meyn house is pictured around 1890. One lasting legacy of John Conrad Moehling was that he convinced John Meyn to move to Mount Prospect and open a blacksmith shop. John Meyn's son, Herman, was Mount Prospect's second mayor, and there are still family members in the community. This is the first house built for the Meyn family. It was built in 1890 and was the first exclusively residential house built in Mount Prospect. This building is a perfect example of neoclassical architecture, which was made very popular across the United States following the Columbian Exposition of 1893. It originally stood on Northwest Highway but was later moved.

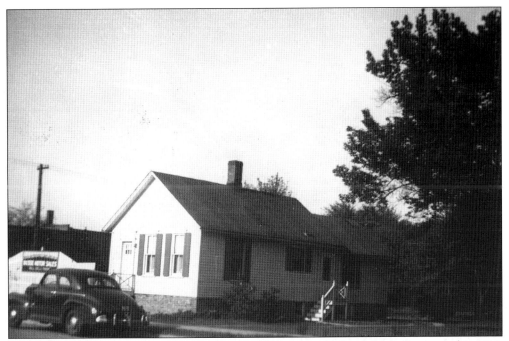

The first Meyn house was moved from its original location to 31 South Main Street, and in 1913, it became the first home of St. Paul Lutheran School. This picture was taken in the spring of 1946, and one can see that the architectural details have been removed.

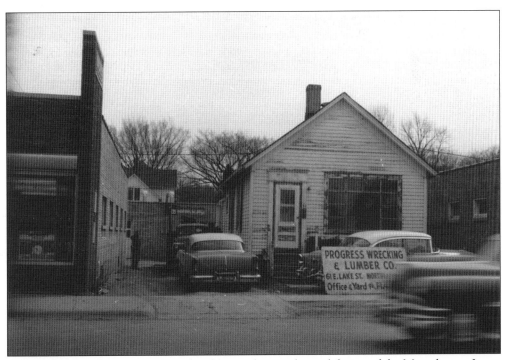

After years of neglect, it was pretty hard to see the neoclassical design of the Meyn house. It was demolished in 1959.

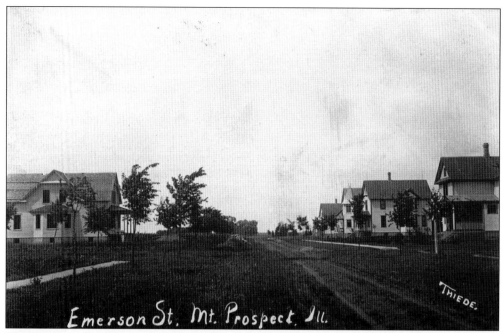

This picture is from Busse Avenue, looking toward Central Road, in 1909. It shows the houses of a small town on the edge of the prairie. Of the houses that can be seen in this picture, there is only one that is still standing, the house on the far right.

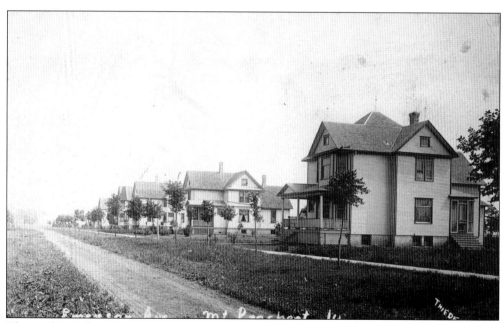

This is almost the same view from four years later. One can see that the town has developed a little more. There are more houses and the trees are a little bit taller. Of the houses that can be seen in this picture there is only one that is still standing, the second house from the right.

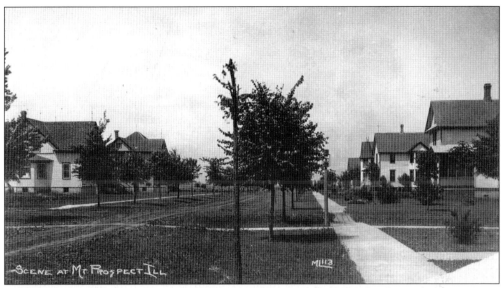

This picture is of the same stretch of Emerson Street. It is a little bit harder to date, as it is not postmarked like the first two. Based on the fact that there is a kerosene street lamp, but the road is not paved, it must be around 1918. One can see how much this block developed in the 10 years since the first picture of Emerson Street. This was the birth of a small town in rural America. Of the houses that can be seen in this picture two are still standing. The house on the left, that is slightly further away from the camera, is the Albert Busse house that was moved to Pine Street in 1960, and the house on the far right is still standing.

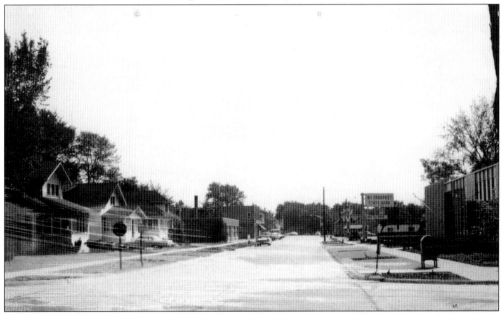

This picture of Emerson Street is from 1968, about 50 years later. Of the three houses that are on the left side of the photograph, the closest one was moved to Maple Street and at least one, if not both of the other two, was demolished to make space for the parking lot of the Mount Prospect State Bank building (now Chase Bank). The bank building on the right side of the street was later used for the village hall and was eventually demolished in 2003.

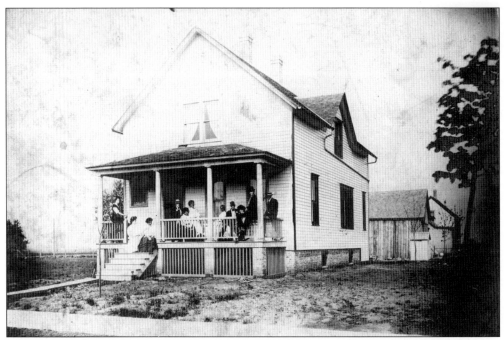

This photograph is not in great shape, but it shows 7 South Emerson Street in 1915. The site is across the street from the Mount Prospect Public Library and has been a parking lot for many years.

This house stood at 3 South Emerson Street and was demolished, along with some of its neighbors, to make way for a parking lot. This lot has since been sold to be developed into a site for townhouses.

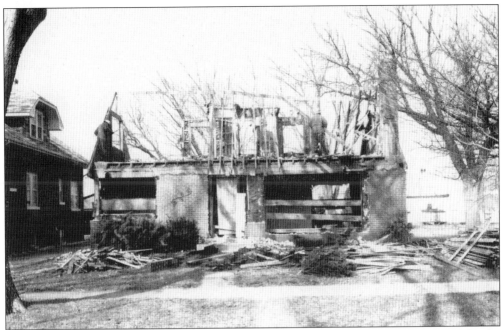

The building that is today the Chase Bank building on Busse Avenue was built in 1975 for the Mount Prospect State Bank. When the building was built, a number of the older houses in Mount Prospect were demolished. This photograph shows the demolition of 110 South Maple Street.

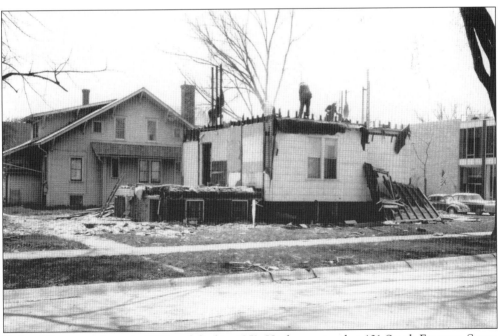

Richard Busse was born in 1900 and died in 1952. His home stood at 101 South Emerson Street and was demolished in May 1966. It is not clear why this building was demolished, but nothing was built on the site in the following years. It is today the parking lot for the Chase Bank building.

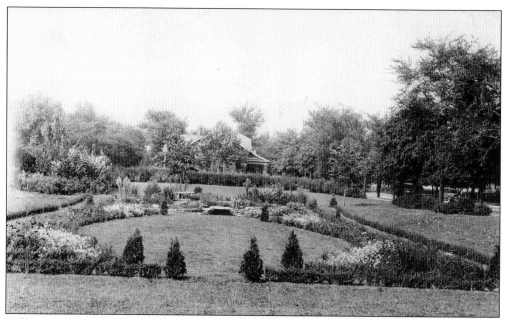

William Busse was very important to the development of Mount Prospect in the early 20th century. Like John Conrad Moehling who preceded him, William Busse was a huge promoter of the community. Busse was a Cook County commissioner and he used this position to steer development toward Mount Prospect. He also used his house and his formal gardens, pictured here around 1927, as a showpiece for the community.

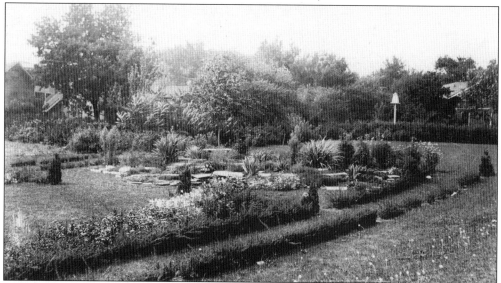

William Busse was born in Illinois in 1864 to a German immigrant family. Like most of the residents of the area, he grew up on a farm and was part of a very tightly knit community. Although the community he was born into tended to be closed to outsiders, Busse soon began to reach out to the larger world. He became a Cook County deputy sheriff by the time he was 26, and a few years later became a Cook County commissioner. He founded the Mount Prospect State Bank, Busse Buick, and Busse Biermann hardware, and used his house and formal gardens to demonstrate his position in the community.

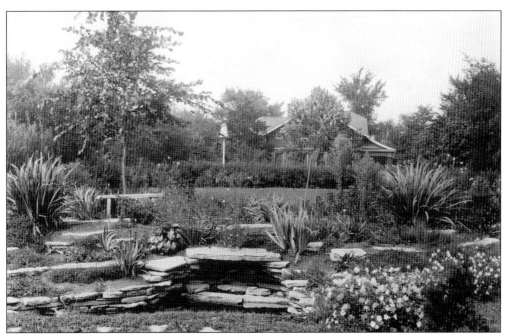

William Busse's first house (not seen here) was moved twice, first in the late 1920s and then again in 1958, while his second house, seen in the background, was moved in 1958. His impressive garden was demolished and is now the parking lot behind Central Continental Bakery.

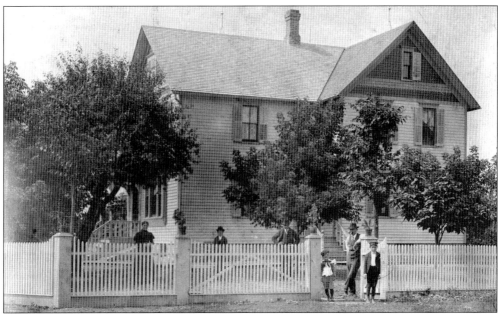

The Louis Busse farmhouse stood near the intersection of Route 83 and Oakton Street. It is seen here around 1899. The intersection is now made up of two gas stations, the grounds of a water reclamation plant, and a parking lot for a strip mall. Louis Busse is seen standing at the gate with his sons, Arthur and Fred. Louis and Fred Busse later founded the Busse greenhouses, which became Busse Flowers and is still open today.

The Wille family was one of the four founding families of Mount Prospect. William Wille built a number of the important buildings in the young community. He built the Central School, Wille Hall, Wille's Tavern, and a number of houses around the community. This was the Wille house, located near the corner of Main Street and Busse Avenue. It is not clear when it was demolished, but it does not appear in the 1920s aerial photographs, and it certainly is not still standing at its original location. An interesting part of this 1900 picture is that one can see the Central School in its original location in the background.

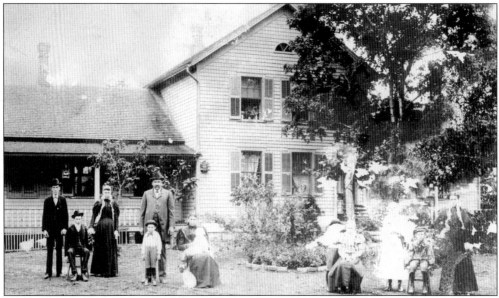

The Garlisch family, like all of the early settlers in Mount Prospect, were immigrants. The community was founded by German immigrants who came to the area to establish a traditional German community and generally wanted to remain separate from the larger American community. This photograph shows the Garlisch Farm, which was on Higgins Road, around 1900. The people pictured from left to right are Louie Jr., Charlie, Martha, Louie (father), Paul (son), Caroline (mother), baby Alfred, Jud, Willy, Carrie, John F., and Amanda.

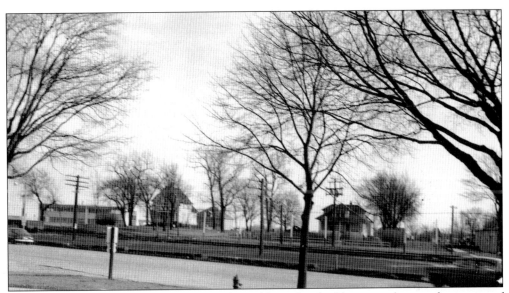

This photograph was taken from where the public safety building is today, on the corner of Northwest Highway and Maple Street, around 1958. Looking across the railroad tracks to Prospect Avenue, one can see the Sporleder and Dunteman houses. The house on the left is Sporleder farmhouse, demolished in October 1981 to make space for a commuter parking lot. The house on the right is the Dunteman house, former home of Alvina Wille and Chester Busse. The house burned and was then demolished; the site is now the location of the Busse Car Wash.

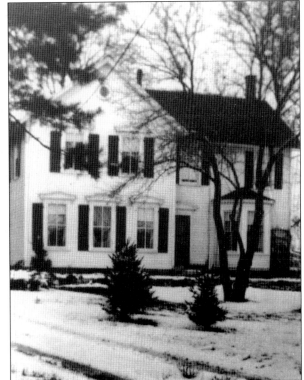

This house stood at 900 West Northwest Highway. The house was originally built for August Linnemann, one of the descendants of Christian and Dorothea Linnemann, the first German immigrants to Mount Prospect. At the time this photograph was taken in 1956, it was owned by Walter Gallee. The house was demolished to make a parking lot for a medical center.

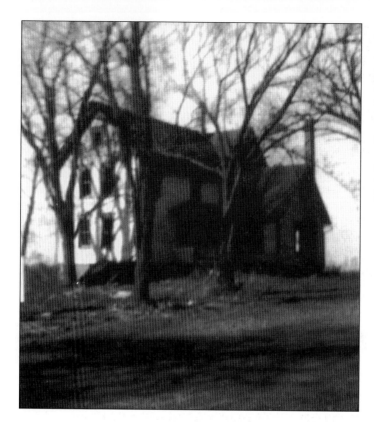

The Miller-Tegtmeier family homestead was built around 1866. This picture was taken in the late 1940s. The farm was one of the longest running farms in the community and was still in operation into the 1950s. The home was demolished in 1958 to make way for the construction of Randhurst Mall.

This photograph is also of the Miller-Tegtmeier family farm in the late 1940s. The farm was first cultivated around 1864.

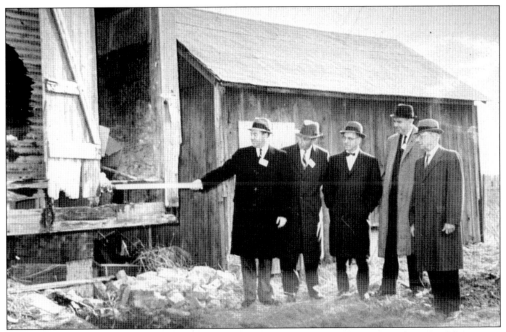

The Miller-Tegtmeier family farm came to a dramatic end. The house and outbuilding were lit on fire by the head of Carson-Pirie-Scott as the land was cleared for the construction of Randhurst Shopping Center. The land was cleared in 1958 for the construction of what was, at that time, the largest enclosed shopping center in America.

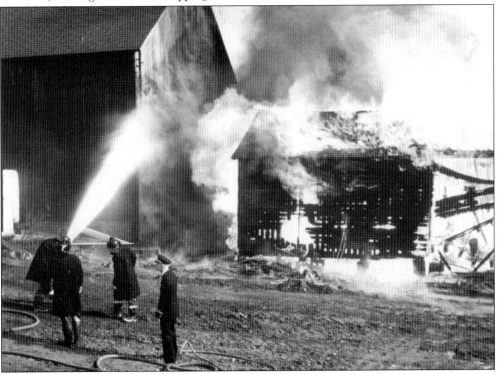

The Mount Prospect Fire Department used the burning of the buildings for a training exercise.

This was the end of the Russell family farmhouse. This photograph was taken in 1942, and it seems that the house was abandoned. The 19th-century farmhouse stood at 211 West Kensington Road. It was allowed to deteriorate and was eventually demolished. The area was not developed until 1954, when the Randview Heights subdivision was platted onto the farm.

The first of the German settlers to come to Mount Prospect were the Linnemann family, who arrived in 1847. They came before the Busses, the Moehlings, the Willes, the Meyns, and the Moellenkamps. Their original homestead was replaced with this building in 1901. It stood at 1200 South Linneman Road and was demolished in 1972.

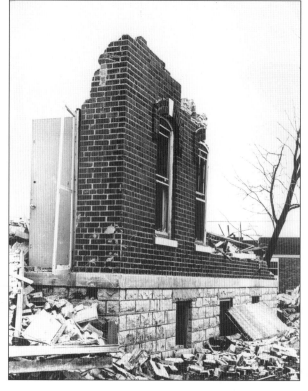

Four
Lost Public Spaces

Churches, schools, and municipal buildings are often the most susceptible to population changes. This can be seen clearly in Mount Prospect as the community faced huge pressures on the schools in the 1950s and 1960s and built a number of new schools. In the following decades, the community faced falling enrollments and sold or demolished many of the buildings. Some of the churches have also seen rapidly rising membership and have chosen to build new structures and demolish their older buildings. This chapter looks at some of the interesting buildings that have fallen victim to either growing populations or declining memberships.

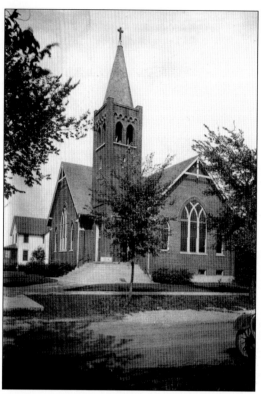

As the German immigrant community developed into the community of Mount Prospect, one of the early important developments was the founding of St. Paul Lutheran Church. The founding of this church signified a shift from the exclusive community, centered on the farms, to a more outward looking town, focused on the train station and connections to other communities. The charter for St. Paul was signed in 1912, and this building was dedicated in 1913. Seen here around 1920, this was one of the most beautiful churches ever built in Mount Prospect and was a truly classic design.

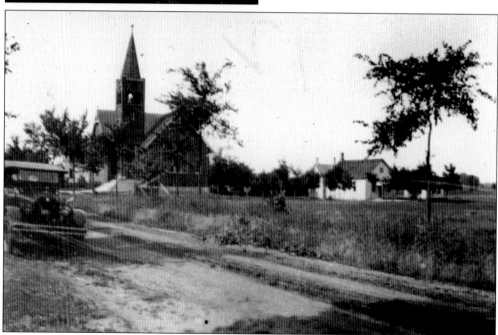

On May 18, 1913, St. Paul dedicated its first school on the corner of Busse Avenue and Elm Street. As the town grew, the church and school grew with it. In 1917, the first full-time teacher was hired, Martin H. Hasz. He began as the only teacher and remained with the school until he retired in 1968. The building is pictured here around 1925.

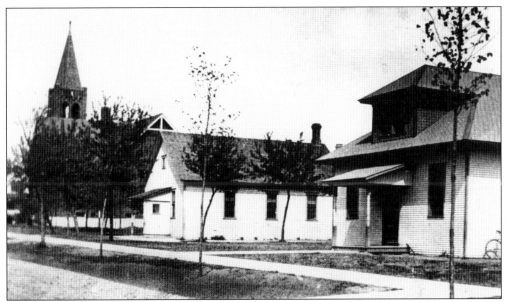

The frame building in the middle of this c. 1920 photograph was the first school, the building on the right was the second. The building on the right was moved to 10 South Elm Street in about 1926 and became the home of the principal, Martin Hasz. The original building for St. Paul Lutheran Church was a landmark in Mount Prospect and helped to define the community. However, it did not meet the needs of the church. A new church was built in 1961, and the original church was demolished shortly after.

In 1928, a new school was built for St. Paul Lutheran Church. This building was designed by the well-known Chicago architecture firm of Zook and McCaughey. In 1956, the fourth school building was erected, which still stands today, although it has had some significant additions. The Zook and McCaughey school was demolished in 1989 to make space for an addition to the 1956 building.

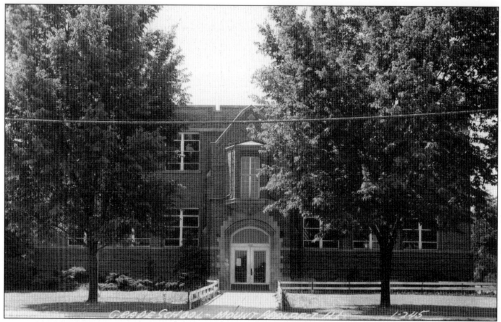

The second Central School, or the Central Standard School, is one of the best remembered schools in Mount Prospect. It was built in 1927 and at the time was a great leap forward. Mount Prospect went from having one classroom for the entire town to having five.

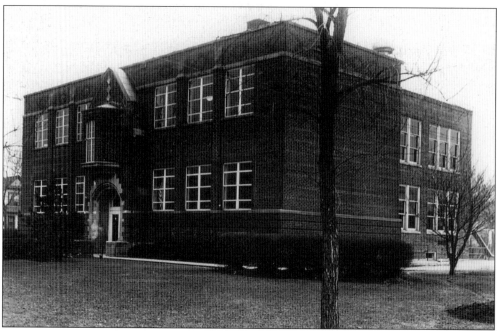

The Central Standard School was originally four rooms, which the community saw as a big improvement over the old one-room schoolhouse. Over the years, it was expanded a number of times. The first addition was built in 1937 and can be seen in this photograph from around 1940.

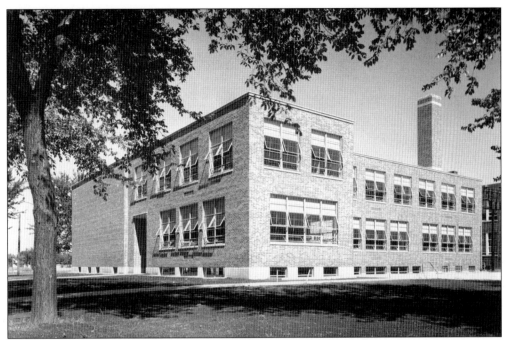

There were a number of additions to the Central Standard School. Over time, the additions to the school became larger than the original school. This 1957 view from Main Street shows the 1948 addition to the school.

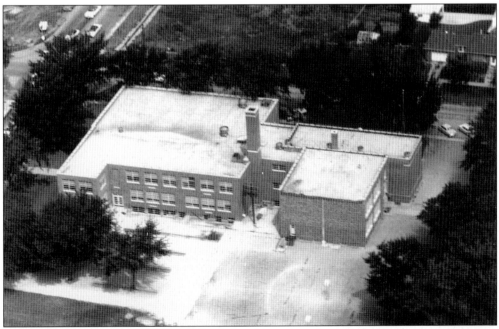

This 1956 aerial photograph shows all of the additions to the school. The road on the left is Main Street. Looking at the school, the small rectangle on the right-hand side of the photograph is the original Central Standard School facing Central Road. The square behind it is the first addition, and the large addition is to the left.

Robert Ferguson is seen in the Central Standard School around 1965. Ferguson started teaching science and social science to seventh and eighth graders at Central Standard School in 1956. He briefly taught at Lincoln Junior High but returned to Central Standard School, where he stayed for the next 12 years. He became principal of Central Standard School in the last year that it was open, 1969–1970. Following the closing of Central Standard School, Ferguson survived many transitions and was recognized for his ability to keep the schools together in a time of great transition.

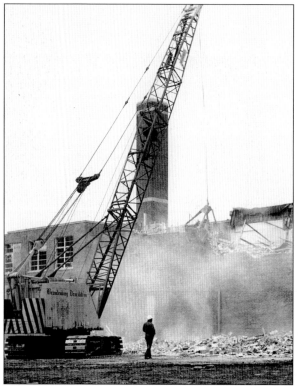

With the boom of students in the 1950s and then the drop in enrollment in the 1970s, many of the schools in Mount Prospect faced insufficient enrollment. In the 1970s and 1980s, many schools were closed, sold, or demolished. In 1975, the Central Standard School, with all of its additions, was razed.

This was the second Feehanville school around 1958. The history of this school goes back to 1882 when Archbishop Patrick Feehan purchased the River Bend Knott Farm with the intention of establishing a training school to house the children displaced or made orphans by the Great Chicago Fire. As a part of this development a small one-room schoolhouse was built on River Road for the local farm children. It opened in 1895. One teacher taught 5–10 students in all the grades. The responsibility for providing room and board for this schoolteacher fell on the neighboring farmers, generally the Runge family and the Piepenbrink family. When the forest preserve took over the land, the school was moved to 1400 Kensington Road. The original one-room schoolhouse was replaced in 1924 by this brick, two-room school, which continued to be used until 1982.

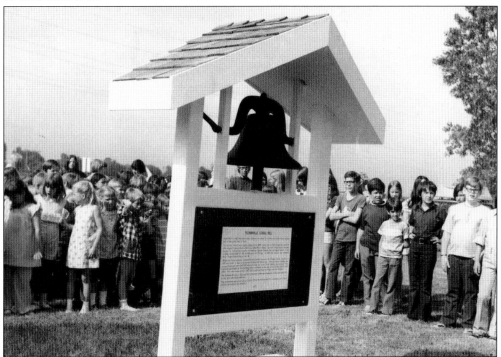

This is the bell from the second Feehanville school. It was rededicated in 1995 to celebrate the 100th anniversary of the founding of the River Trails School District.

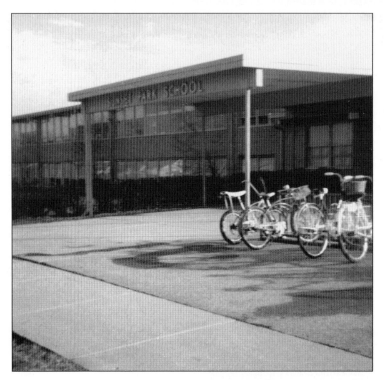

Sunset Park School was built at the height of the baby boom, when Mount Prospect's student population was growing rapidly every year. In 1971, Susan Liston, a first-grade teacher at Sunset, was named Outstanding Young Educator of the Year.

By the end of the 1970s, many of the baby boom children had outgrown the Sunset Park School and the student population dramatically declined. In 1979, School District 57 put the building up for sale with an asking price of $900,000. However, the presence of asbestos and the lack of bidders caused the price to lower to $750,000. There were still no bidders for the site, until the Mount Prospect Park District approached them with an offer of $500,000 for the land without the building. After negotiations, the land was eventually sold for $600,000 in 1985, and the school was demolished. This image dates from 1972.

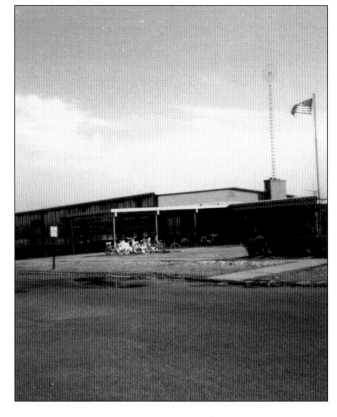

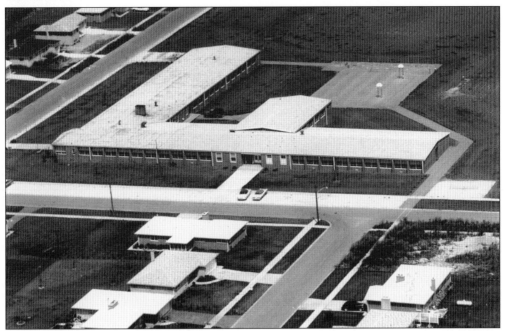

The Busse School was a definite product of the baby boom in Mount Prospect. In this aerial view one can see that the neighborhood around the school was so recently constructed that the trees and gardens had not grown yet. The Busse School stood at the intersection of Owen and Henry Streets and was built in 1956.

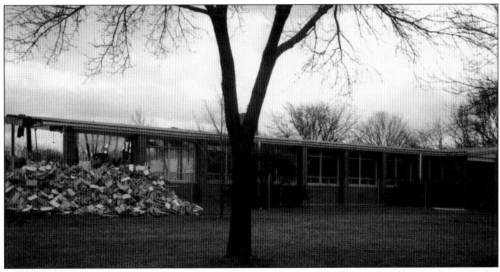

With shifting demographic trends, School District 57 faced declining enrollment through the 1970s. By 1982, the school district was forced to close the Busse School, although there was a large public outcry. In 1987, School District 57 sold the building to the Mount Prospect Park District, which rented the building out to a number of different organizations, and then in 1994 demolished it to construct Busse Park. When the building came down, a number of alumni of the school commented on it being the end of an era of neighborhood schools where parents could see the school from their front porch and the children could go home for lunch in nice weather.

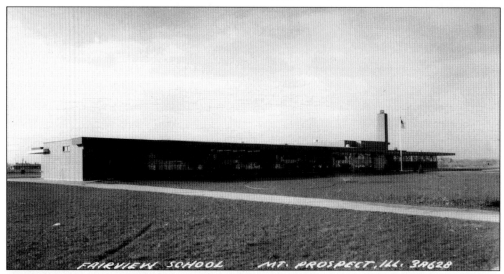

The original Fairview School was built in 1953 and can be seen in this picture from around 1958. It was the first of many schools built in Mount Prospect in the 1950s. The school was vibrant through the 1950s and 1960s and became one of the schools to survive the 1970s. It was even expanded in 1973, with an addition of a multipurpose room. However, as many other schools closed and their students were consolidated into the remaining schools, the original Fairview School was too small and it was demolished in 1994. The new Fairview School was dedicated in 1995.

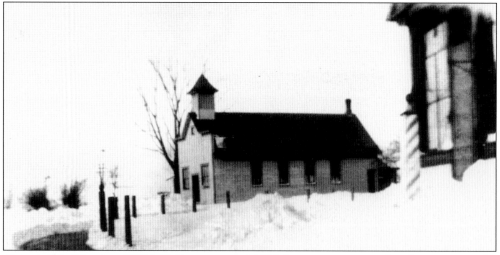

This small building was Wille's Hall, seen around 1923. In some ways, it is a bit of a mystery in the history of Mount Prospect. It was built by William Wille and was used for community meetings. The exact date of the building's construction is not known, but it was during the late 1890s or the beginning of the 1900s. It is also unclear why Wille's Hall was built, as the Central School was already standing and used for community meetings. The hall stood at the intersection of Busse Avenue and Wille Street, and the groups that met there included the Mount Prospect Improvement Association, School District 57, and the early village trustees. This image is undated, but it appears that there is a barber's pole in front of Wille's Tavern, the building to the right. Adolph Wille was granted the first barber's license in 1922, so the photograph may be from close to that date. The building was demolished by the mid-1930s.

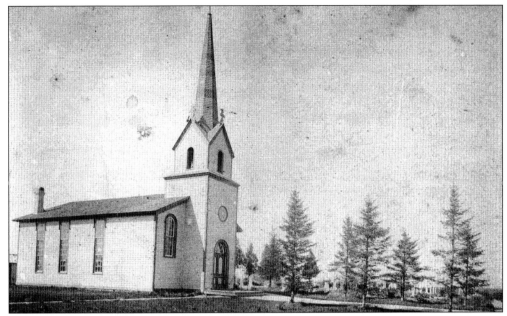

This may be the earliest photograph of any structure in Mount Prospect. It is hard to date exactly, but the picture is of the second St. John Lutheran Church, around 1885. It was built in 1854 under the guidance of Pastor Karl H. Sallmann. This new church housed the growing population of German immigrants in the community. St. John Lutheran Church sold the building in 1892, and it was moved off the lot and the current church was built on the site.

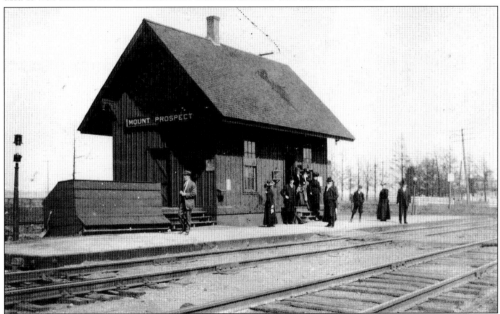

The first train station in Mount Prospect was built by Ezra Eggleston, the community's first developer and the man who named Mount Prospect. This photograph is from sometime between 1910 and 1919—one can see the building for the Mount Prospect Creamery in the background, which was built in 1910, and the kerosene lamps were replaced with electric in 1919. The station was demolished in 1929.

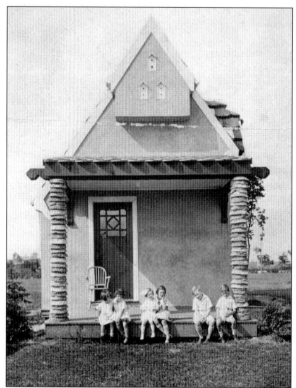

This was the children's playhouse built at the Northwest Hills Country Club, which is today the Mount Prospect Golf Course. This country club was built by Axel Lonnquist, the developer who originally laid out the golf course and the neighborhood surrounding it. He was one of the largest developers in Mount Prospect's first real estate boom in the 1920s. The golf course was constructed first, then the children's playhouse, and finally the clubhouse. This image is from a promotional publication and dates from between 1926 and 1929. The playhouse was later converted into a storage shed, and by the time it was demolished, it was pretty unrecognizable.

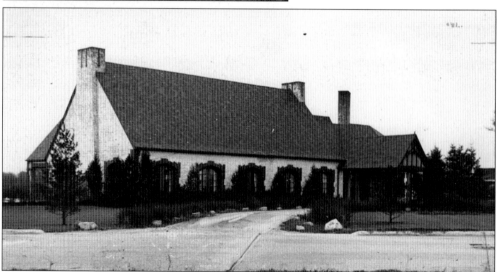

This is an early picture of the Mount Prospect Country Club Clubhouse, around 1929. The original building was built by the developer Axel Lonnquist in 1929 as the showpiece of his suburban housing development. Lonnquist helped to redefine the village of Mount Prospect and, in a small way, suburbs nationally. In the 1920s, when Lonnquist came to Mount Prospect, cities were beginning to be seen as threatening, rather than places of opportunity. Lonnquist played off of this and the history of the glorification of nature, the role of domesticity, and the idea of the home. This, tied to the investment in transportation and the technological advances in housing construction, made it the right time and the right place for a person like Axel Lonnquist.

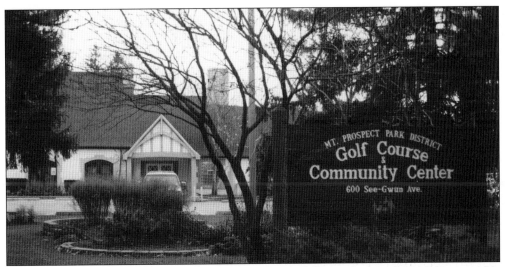

Axel Lonnquist's development in Mount Prospect was different from earlier subdivisions. He purchased the farms of Fred Schaefer and Henry Mensching in 1925 and planned "a luxury community." The crowning glory of this development was to be the Northwest Hills Country Club. His idea was that membership would be associated with owning a lot in his development. He opened the country club in 1926, although it was then only a nine-hole course. He later expanded it to an 18-hole course and, in 1929, opened the clubhouse. The Mount Prospect Golf Course Community Center is pictured here in 2003.

Although Axel Lonnquist was able to redefine Mount Prospect, he was not able to make a lot of money on the endeavor. Due to the timing of his investment, he was not able to sell most of his land before the crash of 1929 and the Depression, which followed. He sold his property in Mount Prospect at huge discounts in 1931 to cover debt. The country club was then sold to a man named Harold Wilson, who changed the name of the club to the more familiar Mount Prospect Country Club. It was sold to Henry Sophie in 1950 and to Richard Hauff in 1958, who was suspected of being a member of the mafia. Hauff redesigned the course to host the Women's Master's PGA tournament in 1959 and then declared bankruptcy in 1960 and put the course up for sale. After an involved fight to pass a referendum, the Mount Prospect Park District finally purchased it in 1961. Over the years, a number of additions were put onto the clubhouse, and it was eventually demolished in 2003.

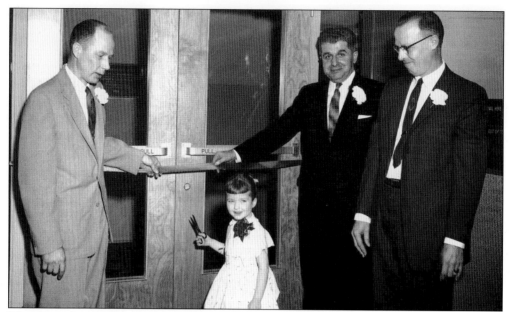

The original post office was inside the Moehling general store, and then the second was inside William Busse's store. There was a more modern post office on Prospect Avenue, which was replaced by this new post office at 202 Evergreen, or the intersection of Evergreen and Northwest Highway. The people in this 1956 picture are Laurence E. Hodges, former postmaster, on the right, and Joseph E. Kruett, postmaster, on the left. The little girl and the other man are not identified. The building was standing until at least 1977, but it is unclear when it was demolished, possibly for the downtown redevelopment in the 1980s.

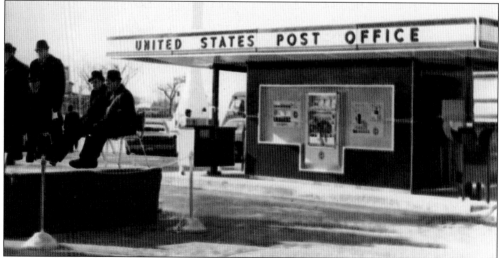

There was also a post office at Randhurst Shopping Center, around 1965. When Randhurst opened, it was the largest shopping center under one roof in America. A million people visited it in its first 28 days being open. When Randhurst opened in Mount Prospect there was a shift of all commercial and social activity toward the outskirts of town and this included the founding of a postal service station. Ironically the movement started by Randhurst toward larger and more isolated commercial developments that were pushed toward the outskirts of towns has led to Randhurst being far surpassed by other malls, and it has struggled like many downtowns.

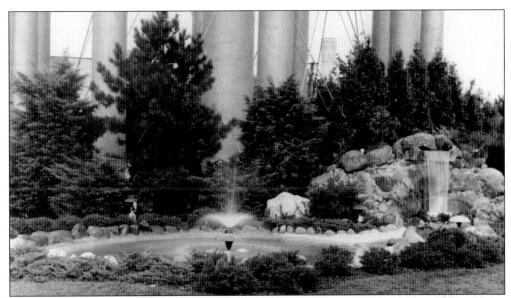

The Whittenberg Fountain, built as a memorial to police chief George Whittenberg, is seen here around 1977. He was the second police officer in Mount Prospect and the second chief of police. Whittenberg was originally hired, in part, because he could ride a motorcycle and the police department had one motorcycle and one 1929 Pontiac. Whittenberg served on the Mount Prospect Police Department for 33 years and was the chief of police for most of that time. He resigned his post in 1965, having seen the community change dramatically during his tenure.

When George Whittenberg started working for the Mount Prospect Police Department the population was about 1,200. By the time he retired, the population was over 25,000. Four years after he retired, he died. His funeral procession included 50 cars that passed by the police station one last time. Whittenberg was a longtime member of the Mount Prospect Lions Club, and following his death, the Lions donated $6,000 to the village to erect a memorial. In 1975, the village built this waterfall and fountain at the base of the water tower, as a memorial to his years of service. The memorial stood very close to the police station in which Whittenberg had spent so much time, but was demolished due to liability fears based on having an open pond in which someone could drown.

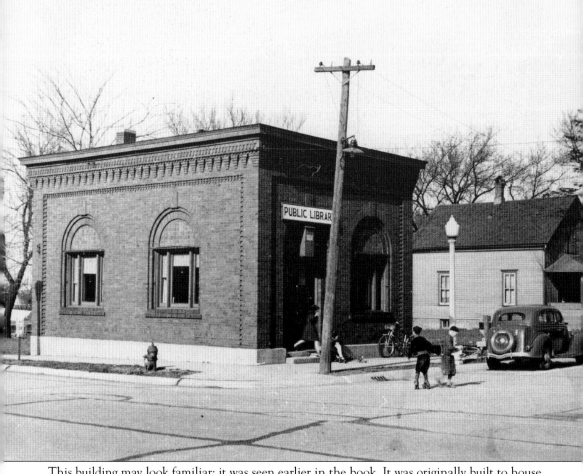

This building may look familiar; it was seen earlier in the book. It was originally built to house the Mount Prospect State Bank in 1911 and was then taken over by the Mount Prospect Public Library in 1932. This photograph dates from the mid-1930s. The library had been established in 1930 by the Mount Prospect Woman's Club and consisted of one cart holding about 300 books that was kept in the cloak room of the Central School on the corner of Main Street and Central Road. In 1932, the library moved into this building on the northeast corner of Busse Avenue and Main Street. The Mount Prospect Woman's Club was still in charge but employed Irma Schlemmer, who was permitted to keep the library open eight hours a week. In 1943, a referendum was passed enabling the foundation of a tax-supported village library. This allowed the library to hire additional staff, purchase more books, and remain open many more hours. Finally, in 1944, the library moved to a paint store at 115 South Main Street, as it was the only store that was open at night and this allowed the library to remain open more hours.

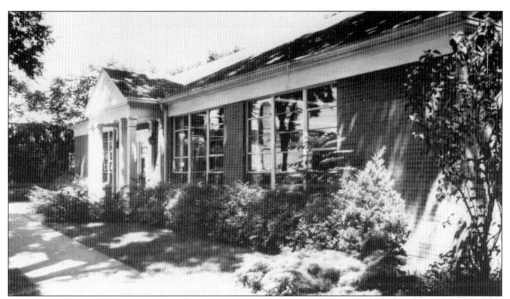

The first building designed to be a library is seen here in 1950, at 14 East Busse Avenue. The land was purchased with $25,000 donated by organizations and from individual gifts. After a bond referendum was approved, the 2,450-square-foot building was constructed. In 1950, the library served a population of 4,009.

In 1961, a second bond issue allowed an addition to the library, and between 1962 and 1966, when this inside image was taken, three other additions were made to the building, increasing its size to 12,000 square feet and serving a population of Mount Prospect that had reached 30,000.

This view shows the inside of the library at 50 South Emerson Street around 1963. By the end of the 1960s, a campaign was begun by the library board of directors and library supporters to acquire rights to the Central School property, where the present library building now stands. In 1974, the population had risen to around 46,000 and the facilities were strained. The village board of trustees voted to purchase the 2.6-acre Central School property as a site for a new library building and approved the expenditure of $3.2 million for construction of a new building. In 1975, the groundbreaking ceremony was held during National Library Week.

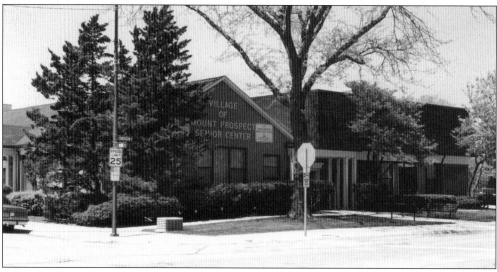

After the library moved out of the building, it was taken over by the Village of Mount Prospect and became the senior center, as well as the home to the human services department and MPTV, or local television services. Seen here in 2001, the building was demolished in 2002 and replaced with the current village hall.

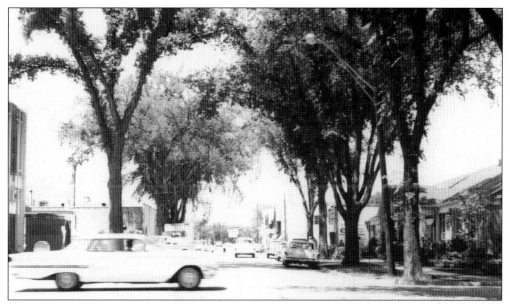

In this 1964 shot of Busse Avenue, looking west, one can see the old Mount Prospect State Bank on the left, which was later used as the village hall; the library on the right, which was later used as the senior center; and the small brick building that was once the home of George Busse Realty. The most interesting thing about this photograph is the trees. These trees were all eventually cut down, perhaps due to Dutch elm disease or development.

The Village of Mount Prospect built the first municipal building in 1923. The small 30-foot-by-30-foot municipal building was constructed by Christ Wille to house the fire department's equipment, village board meetings, the police department, and well No. 1, providing water service for the village. It was attached to the Crowfoot building. After the construction of the larger municipal building on Northwest Highway, the first building was used as storage, a parking meter repair shop, and the Mount Prospect Nurses Lending Closet. In 1977, the historical society took over the small building and offered a Mount Prospect History Museum. This photograph shows the dedication of the municipal museum in June 1977. The person in the center is Mayor Robert Teichert with his wife, Alice. The building was leveled in 1986.

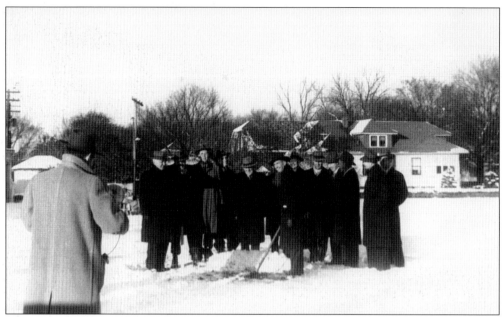

Seen here is the groundbreaking ceremony for the municipal building in 1949. The man in the center is Mayor Maurice Pendelton, who served as mayor of Mount Prospect from 1945 until 1953. This was a time of massive expansion in the community. By far the greatest period of development in the community happened following the end of World War II and the extensive suburban development that followed.

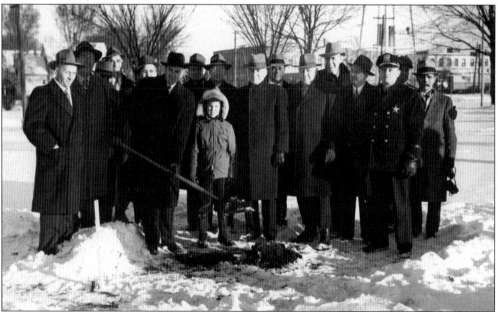

This is also the groundbreaking for the Mount Prospect municipal building that stood at 112 East Northwest Highway. The man holding the shovel is Mayor Pendelton, the man to the right of him in the center of the photograph is William Busse, and the police officer to the far right is Chief George Whittenberg. In the background, one can see the original water tower and behind it the Crowfoot Manufacturing Building.

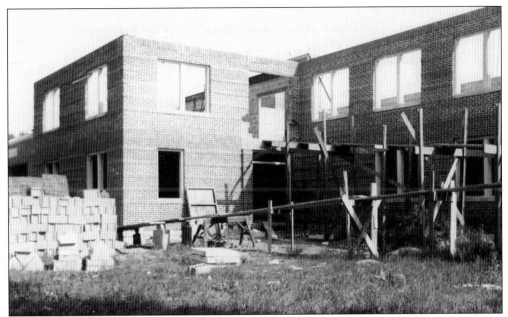

The Mount Prospect municipal building was built in 1949 and replaced the earlier building that had been constructed in 1923. The new building was a free-standing structure and seemed to be a more significant home for the municipal offices. The building was much larger than the first municipal building and allowed the community to offer more services and present a more polished image.

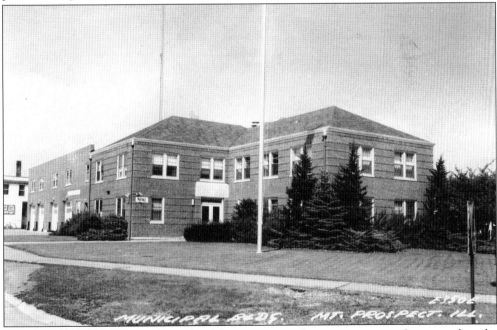

This municipal building was the pride of the community for quite some time. It appeared on the title page of the chamber of commerce's guide to the community for many years and was often the only noncommercial photograph in the phone directories for the village. This image dates from the mid-1950s.

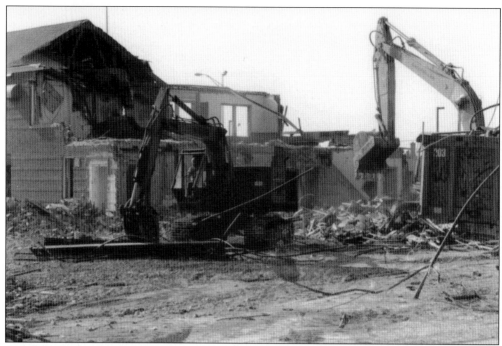

As the community continued to grow, the Mount Prospect municipal building became inadequate. In the mid-1970s, the municipal government and many other departments moved into two buildings along Emerson Street, one purchased from the Mount Prospect State Bank and the other purchased from the public library. The fire department and the police department remained in this building for a number of years, but the building was eventually demolished in July 1991. (Photographs by George Stiener.)

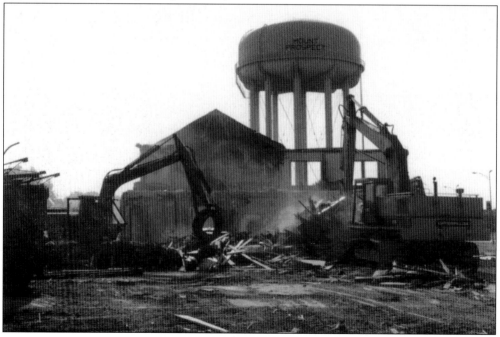

Many Mount Prospect residents will recognize this building as the old village hall. It was actually built by the Mount Prospect State Bank. This is an early image of the building, when it was only a one-story structure, around 1969. It was built in 1967 with the intention of expanding it upwards with a second floor. The second story was added a few years later, and then in 1973, the bank purchased the lots across the street with the intention of building an even larger building. After a few years of negotiating, they did build a new seven-story building and sold this building to the Village of Mount Prospect.

This is the Mount Prospect State Bank building after it was purchased by the Village of Mount Prospect, around 1998. The municipal offices were housed in this building from 1975 until the opening of the current village hall building in 2004.

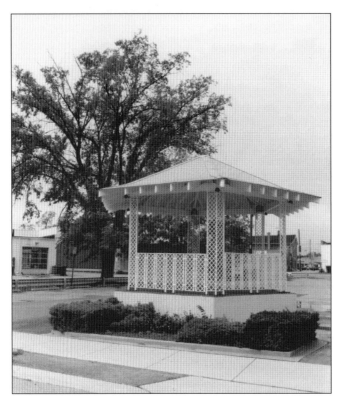

This gazebo was a little piece of public decoration for the village hall. In the 1970s and 1980s, the village hall was seen as both a home of the local government and as a community center. The gazebo, seen here around 1980, was eventually taken down during the development of neighboring property and converted into parking spaces.

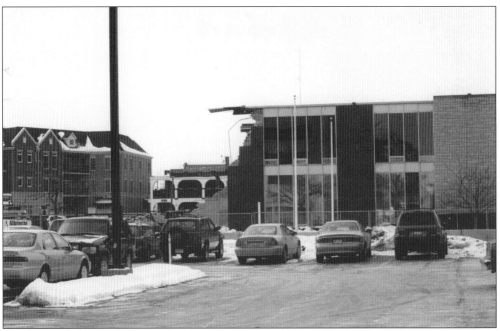

The building that was originally built for the Mount Prospect State Bank and was later used as the village hall was demolished in 2004 to make space for condominiums.

Five
Lost But Not Gone

Some buildings can be altered to the point that their original character is lost even if the building is still standing. In some cases, there can be additions that obscure the original design, or the original features can be removed. Sometimes buildings are radically altered, but the historic character of the structure can still be seen. There are also cases when a building can lose its original character but can be restored. This chapter looks at all of these different fates.

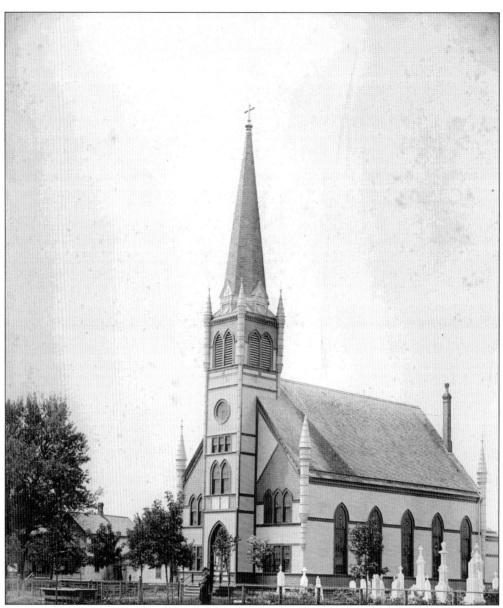

St. John Lutheran Church was the first institution founded in Mount Prospect. It is seen here at the beginning of the 20th century. The German immigrants who migrated to the area that would become Mount Prospect were very interested in preserving their culture and religious traditions. After buying land and supplies, the first thing they did was found a church in 1848. The original church building was replaced by a larger church in 1854. The second church was sold and moved out of Mount Prospect in 1892 and this church was built in its place. This building is still standing today, although it has been radically changed.

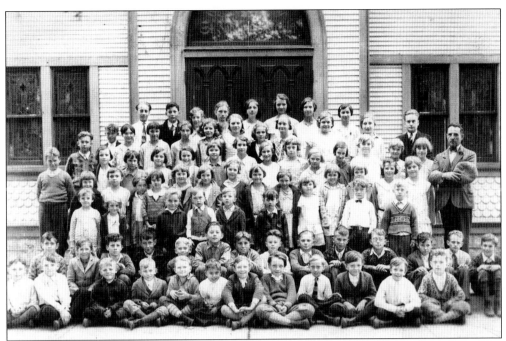

This 1930 St. John Lutheran School class picture shows the original doors and windows of the 1892 church, and some of the ornamental shingle work along the bottom of the building can be seen. It is also interesting to note the writing on the window above the door is in German.

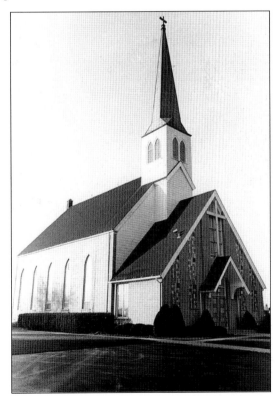

This is the 1892 church today. The building has lost much of its architectural character, in part through accidents and in part through decisions made by church members. An addition to the front of the building was put on in 1962, and the spires on the corners were removed. With the addition, the original clapboard siding was covered. This addition radically altered the architectural integrity of the building. The original steeple is also gone. It was blown down in 1979 in a wind storm and the replacement steeple was shorter and less decorative. The church was standing at the time this was written, although there is a movement within the congregation to build a new church and demolish this structure.

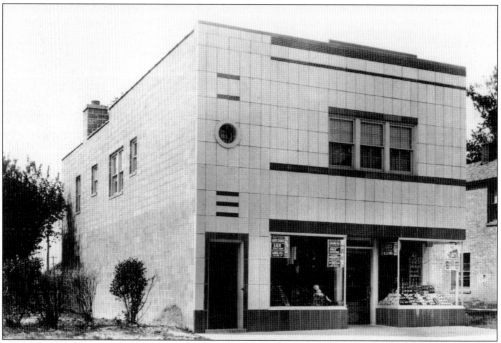

This may be the only truly art deco building in Mount Prospect, seen around 1938. It was built at 15 West Busse Avenue in the 1930s, and originally had this sleek geometric facade. It was built as a grocery store and was a part of the thriving business district along Busse Avenue. The building underwent a number of modifications that obscured the original facade. At the time that this book was written, the building is still standing, although a developer has announced his plans to demolish it.

This photograph shows Frank Gerkin and Ralph Busse who have apparently just come back from a hunting trip in 1954. To the right, 15 West Busse Avenue can be seen behind them with the first modification to its facade. The original tiles were replaced with a stone facade.

Here is a view of Busse Avenue, looking west, in 1965. One can see the 15 West Busse Avenue building with its second front. The sleek tile facade was replaced with an irregular stone facade. It is not known exactly when this new front was added to the store, but it has been recounted that the original facade was removed because some of the tiles had been improperly mounted and the seams were not watertight.

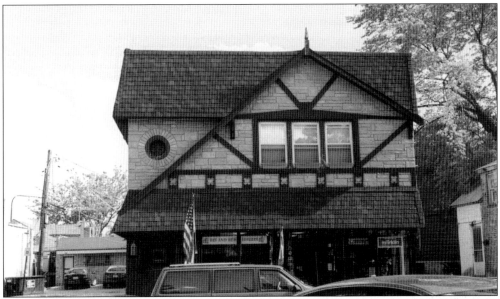

This is the art deco building today, and as can be seen, the original character has been significantly compromised. A radical 1984 modification of the facade involved placing half-timber frame construction along the outside, adding an artificial sloped roof line and an off-centered peak. Ironically the design that completely changed the architectural character of the building was meant to make the building match the historic character of the buildings across the street.

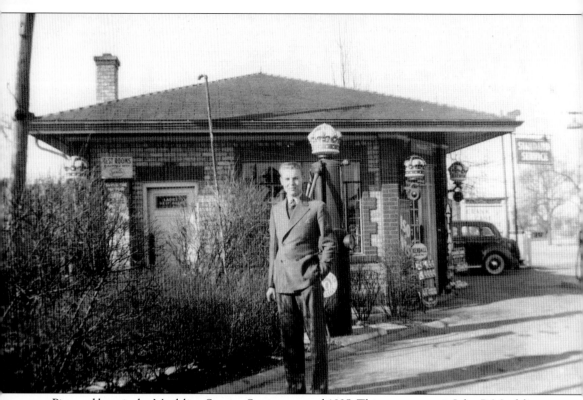

Pictured here is the Moehling Service Station around 1935. This young man is John P. Moehling, the son of the John Conrad Moehling, the owner of Mount Prospect's first store and the first postmaster for the village. John P. is standing outside the Standard Service Station that his father had built for him in 1927. This was a classic filling station. The decorative glass crowns can be seen on top of the old pumps and at the door to the station. This service station remained in business for years, undergoing few modifications. At one point, there was a low brick wall along the sidewalk, but generally the building remained intact into the 1960s. At the time this was written, this building was still standing, although it has been radically changed and its demolition has been discussed.

This is the second police officer and later the second chief of police in Mount Prospect, George Whittenberg, standing with Len Johnson Jr. They are posing with the Henderson cycle in June 1937, the year Whittenberg became the chief of police. Behind them, one can see the Moehling Standard Service Station in its original form.

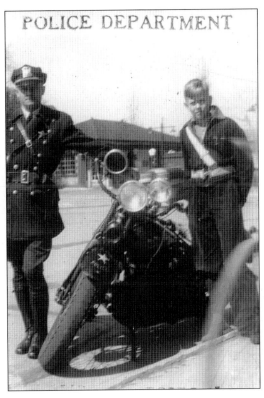

This is the Moehling Service Station as it appears today. One can see that, similar to the building at 15 West Busse Avenue, the original architectural character of this building has been changed, ironically, to make it look more consistent with other historic buildings in the area.

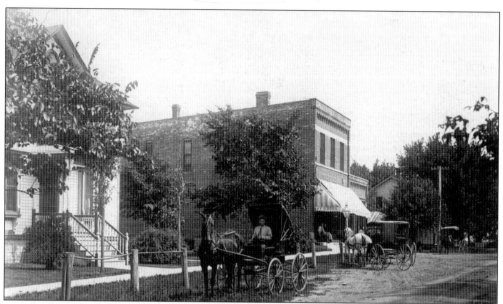

In this great photograph, one can see three buildings, around 1910, all three of which are still standing today, but all have been dramatically changed in one way or another. The white house on the left of the photograph has been moved twice and significantly altered since this image was taken. The building in the distance on the right behind a tree has been added to, subtracted from, beat up, run down, moved, and restored. The building in the middle is still standing on Main Street, but one would never know it.

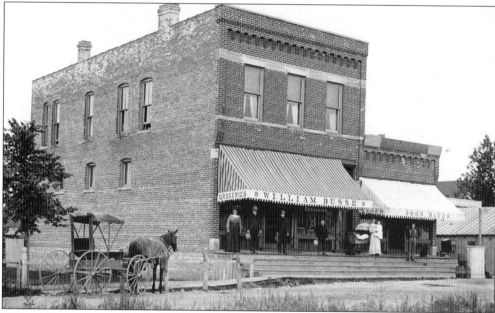

William Busse's store is seen here on Main Street around 1905. William Busse ran a general store that sold groceries, seeds, equipment for farmers, tools, and basic supplies for people living in Mount Prospect. He later built a larger building on Busse Avenue to house his store and sold the grocery part of the store to Fred Meeske. William Busse can be seen in this image standing on the steps; he is second from the left.

Construction of the Busse building on Main Street is captured in this photograph from 1926. One can see William Busse's store, from the earlier photograph, to the right and the corner of William Busse's house to the left. The man in a sweater standing in front of the door is William Busse Jr. The man in the dark suit is John Pohlman.

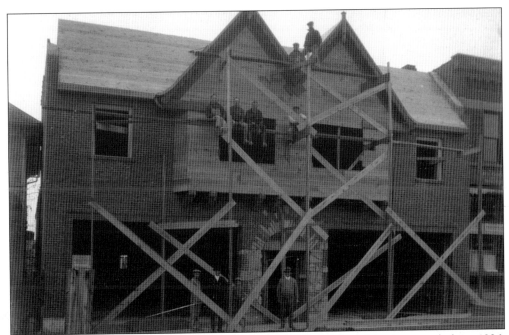

In this image the Busse building can be seen along Main Street, around 1935, more or less as it appears today. The facade of the building, constructed in 1926, was extended to cover the two buildings and make it appear that they were one. In aerial images, one can see that the two buildings are connected along the front and the back of the buildings but that there is a space in the middle.

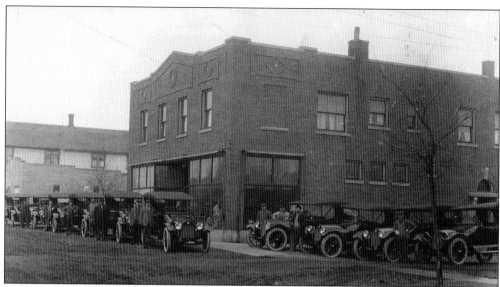

Seen here is 2 West Busse Avenue around 1915. Built in 1912, it originally had a simple flat facade and was used as the home of William Busse's store. When it was built, Mount Prospect did not have electricity or indoor plumbing. William Busse's store grew rapidly from its opening. In fact, before the building was even completed, it became the first car dealership in town. Without a garage, they would display the new cars on the street in front of the hardware store and at night they would roll them into the back of the store. In 1915, they built the cement-block structure that can be seen next door and began to offer full service repairs.

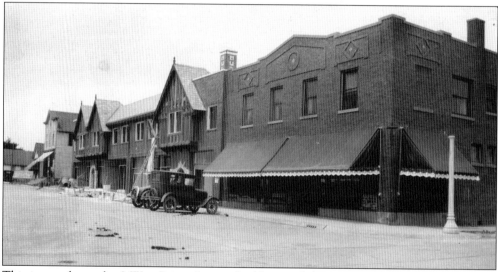

This image shows the 2 West Busse Avenue building and the construction of the other Busse Avenue building in 1927. With the construction of the second building, the 2 West Busse Avenue building became the home of the Mount Prospect State Bank. The store that had been inside it was broken up into three separate businesses. The hardware business became Busse-Biermann hardware, the Buick dealership moved to the building on Main Street and became Busse Buick, and the farm implement business was sold off to the Meyn family. The Mount Prospect State Bank was based in this building through the Great Depression and World War II.

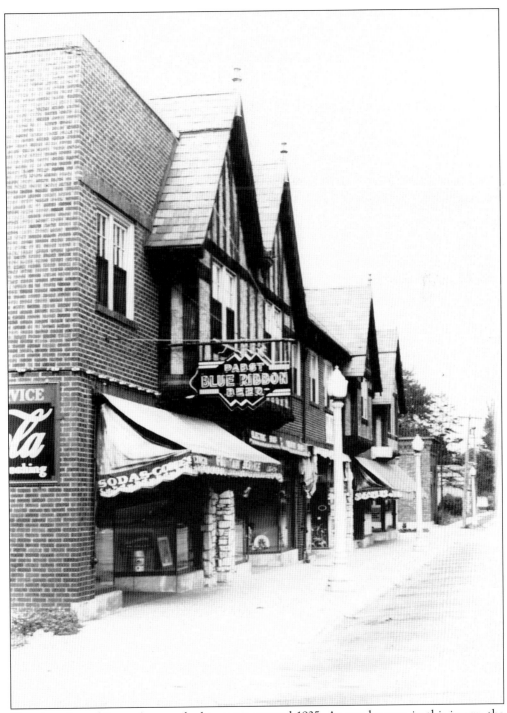

Here is a view of Busse Avenue, looking east, around 1935. As can be seen in this image, the theme of the facade of the 1927 Busse building was extended to the building at 2 West Busse Avenue. Over the years, the facade of the building has been modified a number of times. However, unlike the building along Main Street, it has always been possible to tell that it is a separate building.

In 1967, the Mount Prospect State Bank decided that it needed to move to a larger building. They built the bank at 100 South Emerson Street that later became the Mount Prospect Village Hall. The building at 2 West Busse Avenue became home to a series of different restaurants, including Sammy Skobel's Hot Dogs Plus, Danneo's Ice Cream, Arnold's Diner, a Mexican restaurant, and Ruffini's Italian Restaurant. It is pictured here in the late 1970s.

One of restaurants that was based in 2 West Busse Avenue was Danneo's Ice Cream. This was a classic ice-cream parlor and lunch counter that operated out of this downtown location through the 1970s.

Sammy Skobel's Hot Dogs Plus is seen here around 1980. Sammy Skobel is one of Mount Prospect's local celebrities. He was a famous Roller Derby champion, during the sport's heyday. He was born on Maxwell Street in Chicago and became legally blind at the age of four from scarlet fever. However, Sammy tried out and made one of the Roller Derby teams, without telling anyone that he was blind, and went on to glory in the sport. Following his retirement, he moved to Mount Prospect and started Sammy Skobel's Hot Dogs Plus in 1967. The store was on Main Street in the 2 West Busse Avenue building and became an institution in the community. The restaurant closed in the late 1980s.

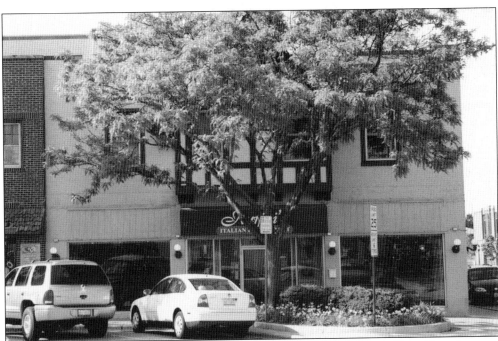

At the time that this was written the building at 2 West Busse Avenue is still standing, however it is now vacant and a developer has announced plans to demolish the building. The most recent occupant was Ruffini's Italian Restaurant, which closed in 2005.

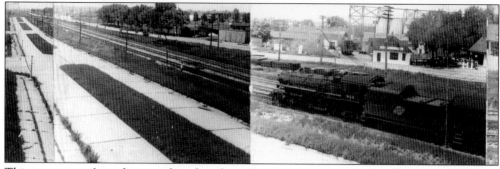

This is a series of six photographs taken from Prospect Avenue and Wille Street in 1938. The first in the series is looking northwest along the tracks and shows the open space and farmlands. The second shows one of the old freight trains running along the tracks and part of Wille's Coal and Lumber. In this image one can see that there is still a side track with a train car pulled over to the Wille Coal and Lumber building.

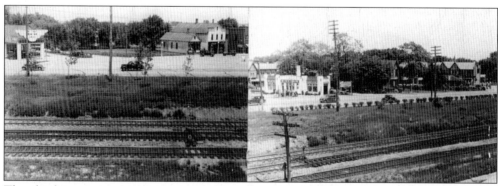

The third image in this series shows the intersection of Wille Street, Busse Avenue, and Northwest Highway. There is a motor sales office to the left, although little is known about that business. To the right one can see the small barbershop built by Adolph Wille in 1923 and next to it Wille's Tavern, built in 1905 by William Wille. Both of these buildings are still standing in this location. The fourth image shows the Sinclair Gas Station that was built where the Meyn blacksmith shop once stood. This is today the Carriage House Restaurant. Past the Sinclair Gas Station, along Northwest Highway, one can see John Meyn's house, the Moehling Gas Station, and across Main Street, the Busse building. All the buildings except the Sinclair Gas Station are still standing.

In the fifth image in the series, one can see the intersection of Main Street and Northwest Highway. On the corner is the Moehling general store, which has since been moved to Pine Street. The train station can also be seen and in the distance Mount Prospect's first water tower and past that, the Mount Prospect Creamery building. The last image in the series is looking along Prospect Avenue to the southeast. Mostly open space can be seen. Faintly one can make out what was then Kruse's Tavern and is now Mrs. P and Me's restaurant.

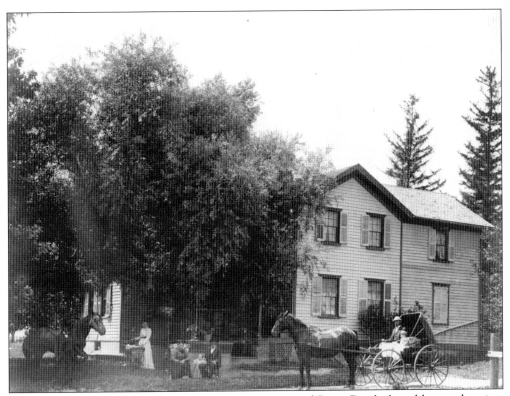

This farm, located near the intersection of Algonquin and Busse Roads, lasted longer than just about any other. The farm was established when people were driving horses and buggies and was still in operation in 2005. It was in the same family, with Allen Busse running the operations and working hard to survive as a small farmer in a landscape of office parks. However, the pressure of development was too much and there have been discussions of selling the lands and the buildings to a developer who will build an office park or light industry development on the property.

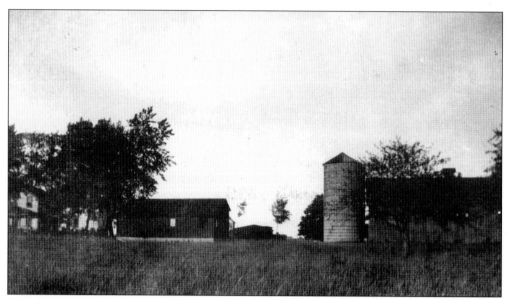

The oldest house standing in Mount Prospect is the Owen Rooney House. The exact date of construction is unknown, but it is believed to be sometime during the 1850s or early 1860s. While it is hard to date, it can be seen from the earliest images that it was built with milled wood, which would have been prohibitively expensive before the construction of the sawmill by Socrates Rand, the man for whom Rand Road is named. In this c. 1920 image, the house is to the far left.

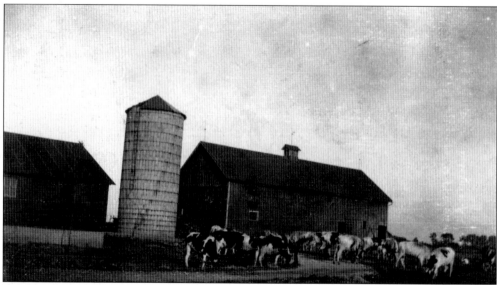

The Owen Rooney House is considered farmhouse vernacular, meaning it was constructed by the owner without the design of an architect. Owen Rooney was an Irishman who came to this area in 1847 after living in the Northeast. He bought 160 acres of land and farmed the land with his wife, Ann, and their seven children. Rooney sold some of the original acres to Ezra Eggleston, who platted the first development of Mount Prospect in the 1870s. The Busse family purchased the house and the rest of the farmland in 1916 and owned it until 1924.

The house has gone through a variety of owners since then and has undergone a number of additions and changes. Originally the house consisted of only two rooms until around 1900 when an addition was added to the right of the entrance. In the late 1920s, the land surrounding the farmhouse was subdivided into what became known as the Busse Eastern Addition. The house was again remodeled around 1929, adding arched walkways, stucco walls, and other contemporary designs. Since then, the house has undergone a number of interior and exterior renovations.

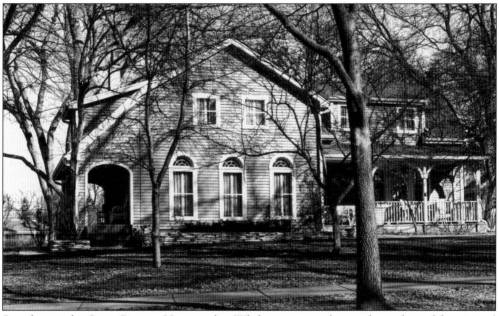

Seen here is the Owen Rooney House today. While one can make out the outline of the original house, the building has been significantly changed. What was the front of the house is now the side; the windows have been arched, and there has been a series of additions put on the house. From a historical standpoint, it is nice that the building is still standing, still occupied, and is still in its original location. Unfortunately much of the original character has been obscured.

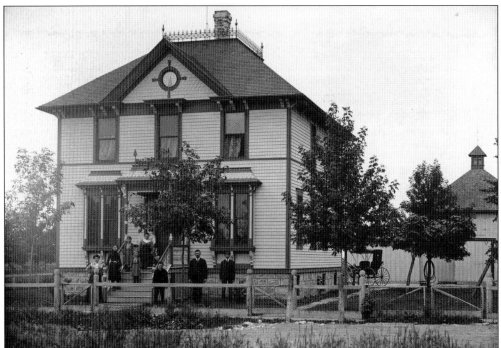

This is William Busse's house in its original location and in its original form around 1899. His house was the most formal in the community and was meant to convey his stature in the region. The house was built in 1894 with a combination of Victorian decoration that can be seen in the ironwork around the widow's walk on the roof, the brackets along the roofline, the decorative shingle work above the windows, and a basic foursquare design that can be seen in the simple box design, the central dormer window, and the hipped roof.

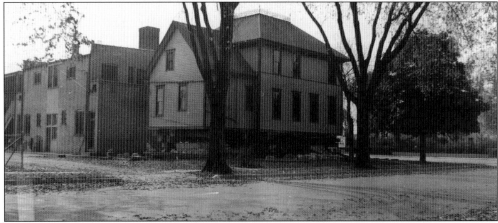

William Busse's house was moved from its original location to Emerson Street in the late 1920s. One can see the building being picked up in this photograph. The Busse building on Main Street, which was built in 1927, is next to it. William Busse wanted to develop Main Street as the commercial center of the community and felt that the lot that his house was sitting on could be more effectively used as a commercial space. Once the building was moved, Meeske's Market was built on the site. The building that housed Meeske's Market is still standing and is now home to the Central Continental Bakery.

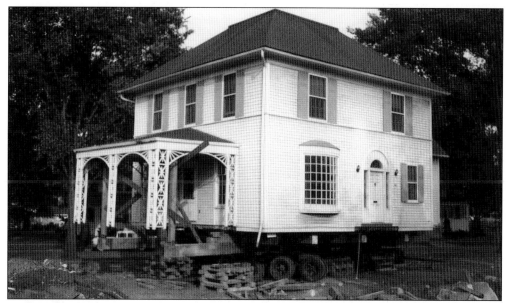

William Busse's house was moved a second time in 1958. One can see that by the time the building was moved for the second time, much of the distinctive design had been removed. The ironwork around the widow's walk is gone, the decorative shingle work has been covered or removed, and the central dormer window has been taken out. The building had also been rotated 90 degrees and the original main entrance was made into a side door onto a patio, and a new entrance, along with a bay window, was added to one of the sides.

This is William Busse's house today. From a historical standpoint, this is a mixed bag. The architectural character of the building has been significantly altered. Because it was rotated it no longer appears as a foursquare design, and the removal of all the original detail has taken away the Victorian character. The arched entryway and bay window are inconsistent with the historical character of the building and, of course, the attached garage detracts from its historical value. On the other hand, it is still standing and allows residents to see a little bit of the community's history.

William Busse's second house is seen here around 1940. Busse built this house in the 1920s and gave his first house to his oldest son. As he grew older, and his children grew, he felt that he did not need such a large house. This house originally stood on Emerson Street at the corner of Busse Avenue. This is a classic brick bungalow and, like his first house, demonstrates William Busse's knowledge of the current architectural styles and movements.

His second house was also moved to Central Road in 1958. In this picture, the building is rolling down Emerson Street to Northwest Highway. The building to the left is the Texaco Station that can be seen earlier in this book. To the right, a house on Emerson Street, which was moved to Maple Street 20 years later and is featured later in this chapter, can be seen.

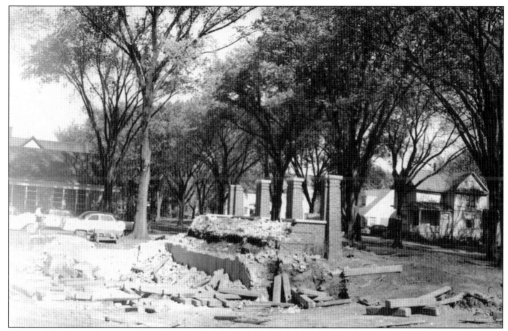

This is the site that was left behind when William Busse's second house was moved in 1958. As one can see, the front porch did not make it to the new location. To the left, the building constructed as the Mount Prospect Public Library, which was later used as the senior center, can be seen.

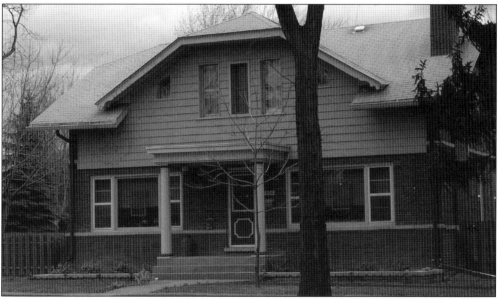

This is William Busse's second house today. Similar to his first house, it is nice that the building is still standing and can be seen by people interested in the history of the community. However, also similar to William Busse's first house, a significant amount of the architectural character of the building has been altered. The front porch was left behind when the building was moved, which changed the original slope of the building. The removal of the porch also led to covering the brick with siding.

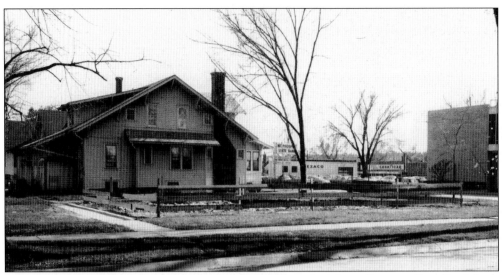

Pictured here is 103 South Emerson Street in 1966. When the Mount Prospect State Bank built the seven-story building on Busse Avenue there was a significant shift in the downtown. That block, bordered by Busse Avenue, Emerson Street, Maple Street, and Northwest Highway, had been split between commercial and residential areas. The area near Northwest Highway was commercial while closer to Busse Avenue had been residential. The Mount Prospect State Bank bought up the northern half of this block and either moved or demolished all the houses to build the large bank and office building. This photograph shows the Christine Busse house in its original location.

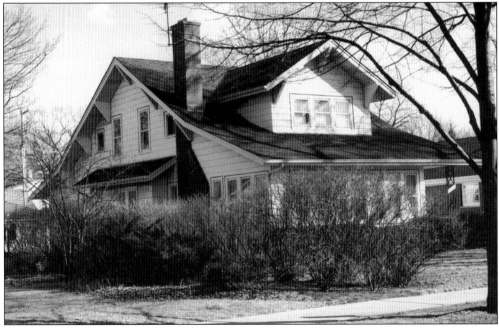

The Christine Busse house was picked up and moved one block, from its original location at 103 South Emerson Street to its current location at 105 South Maple Street, in 1974 to make way for the construction of the Mount Prospect State Bank building and its parking lot. Here it is as it stands today.

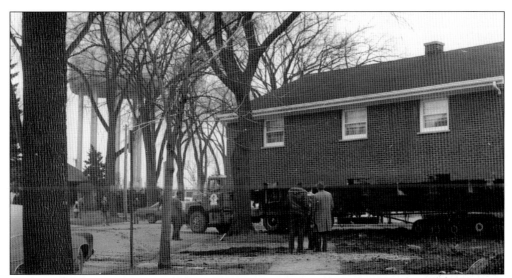

Here is a 1974 photograph of 107 South Maple Street. The 100 block of Maple Street is a very mobile neighborhood. This house was originally on Emerson Street and it was moved to South Maple Street, or next door to the Christine Busse house. This house was also moved to make space for the Mount Prospect State Bank building, which is today the Chase Bank building. With any project that involves moving buildings, there are costs and benefits. The homes that were moved to build the bank lost a part of their historical character when they were moved from their original sites. However, they are all still standing, which is a benefit to the community's history.

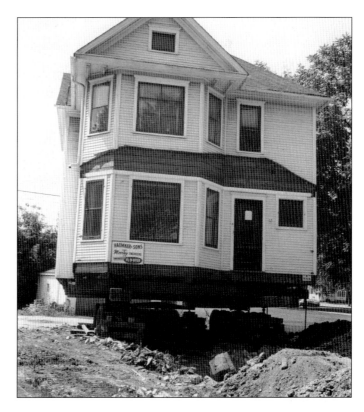

Pictured is the Albert E. Busse house at 3 North Pine Street in 1960. Mount Prospect has a long history of moving buildings. This house was built in about 1907 by William Wille and Henry Beigel for Albert Busse, the son of William Busse. Albert helped run the Busse Buick dealership and later sold this house to Herman Wuerffel, the president of the Utility Battery Company, the company that first made electricity available in Mount Prospect.

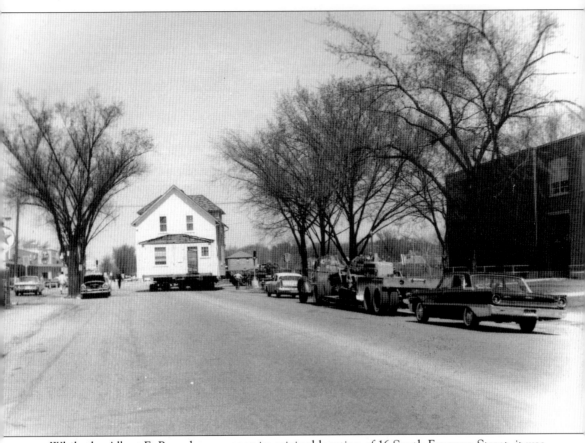

While the Albert E. Busse house was at its original location of 16 South Emerson Street, it was purchased by School District 57 and used as administrative offices. In 1959, the school district sold the building at auction and had the new owner move the building. In this image, one can see the house moving down Main Street in 1960. The Central Standard School can be seen on the right side and the old A&P grocery store is on the left.

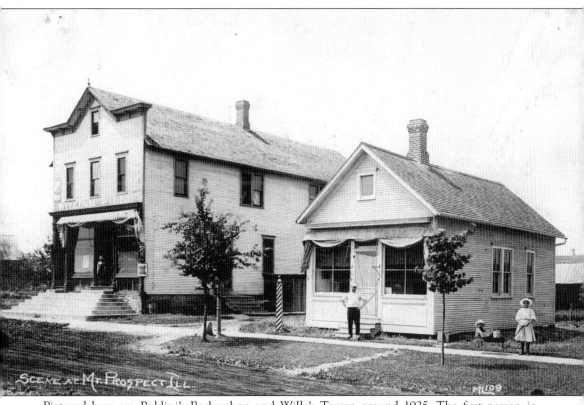

Pictured here are Baldini's Barbershop and Wille's Tavern around 1925. The first person in Mount Prospect who was given a barber's license was Adolph Wille, who put a barber's chair into Wille's Tavern in 1922, in part to help support the business during Prohibition. The barber chair was a success, so Adolph Wille built the small building to the right to become a separate barbershop and brought in a professional barber named Baldini in 1924.

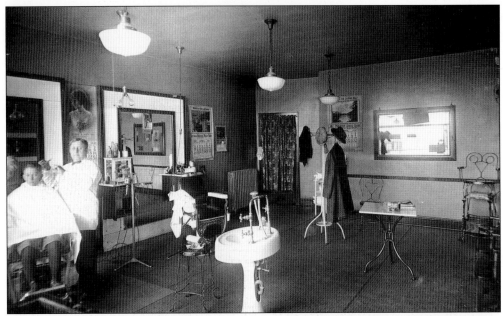

This is an interior image of the Baldini barbershop from 1927: a truly classic barbershop from a different era.

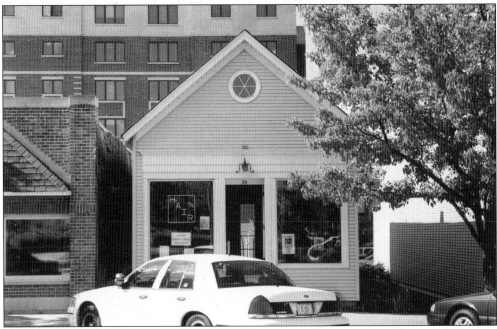

Shortly after the barbershop was built, it was moved to the other side of Wille's Tavern. Looking at aerial photographs from 1926, two years after the construction of the building, one can see the building has been moved. It is not clear why the building was moved such a short distance, although it has been said that there was some disagreement about property lines. It may be that it was moved to make the construction of the 1927 Busse building possible. Over the years, the building has also been modified. The center window was originally square and it is now round and the siding has been covered or replaced.

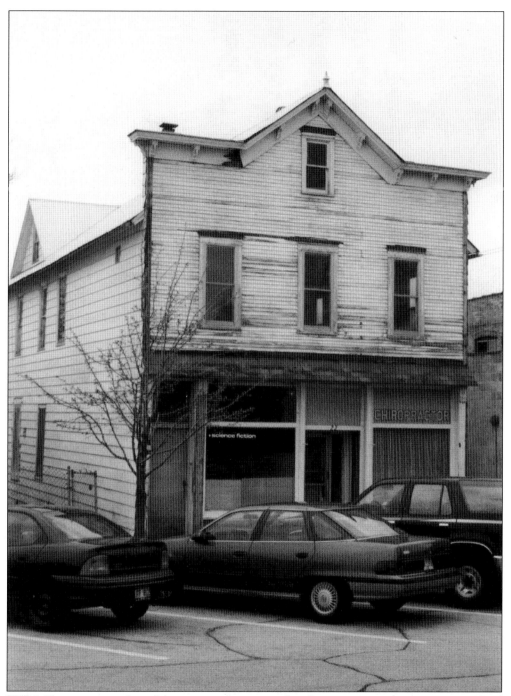

Wille's Tavern was neglected for years and was considered an eyesore in the community. Vinyl siding was put on the sides, the wooden clapboard in front was in bad shape, and the interior was ripped up. Wille's Tavern remained open through the 1980s, but it moved to a small brick building a few doors down in 1951. The original building was used as a chiropractor's office, a comic book store, a storage space, and a number of other uses. By the 1990s, as seen here, the building was in bad shape.

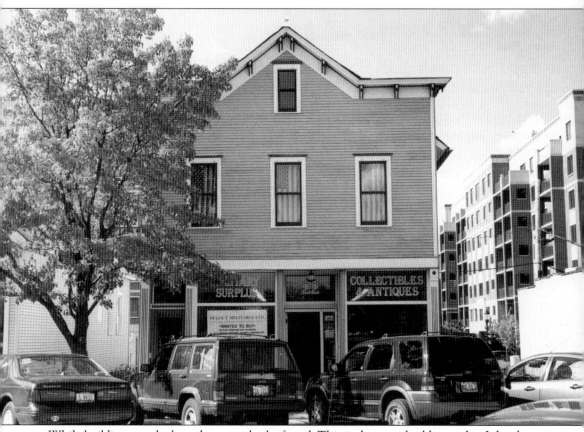

While buildings can be lost, they can also be found. This is the same building today. It has been restored by its current owner, who runs a healthy military surplus business out of the storefront. The building is now one of the anchors of the block.

John Conrad Moehling owned and ran the first store in Mount Prospect. He was the first big promoter of Mount Prospect and the first postmaster. Moehling's general store can be seen in the background, while he can be seen in this photograph standing in the front, wearing a hat, with his son John P. Moehling in front of him around 1886.

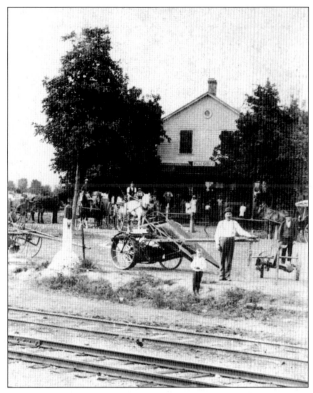

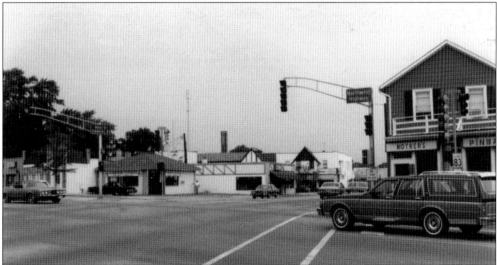

Over the years, the Moehling general store deteriorated. In this 1980 photograph one can see that the building had a number of additions built onto it, including new shingles that covered the central window. However, the main addition is a new front on the first floor that extended out to Northwest Highway. The original building was constructed years before Northwest Highway was laid out, so it did not follow the diagonal direction of the street. In this photograph, one can also see the Submarine Express sandwich shop that was housed in the building formerly home to the Moehling Service Station. The building has been modified, but this image precedes the addition of timber framing. Danneo's Ice Cream can also be seen in the background.

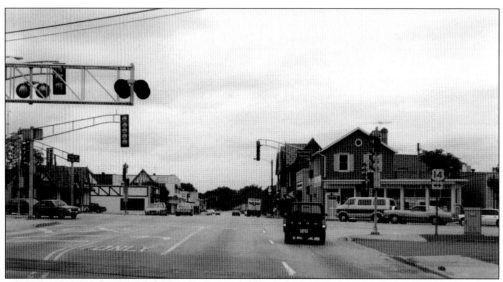

This photograph also shows the intersection of Main Street and Northwest Highway from the railroad tracks around 1990. Compared to the 1980 photograph, the central window has been returned to the Moehling general store and one can see the full addition to the front of the first floor. In this picture, one can see that Submarine Express has been renovated and a sharper peaked roof has been added, along with the timber-framed facade. The facade of 2 West Busse Avenue has returned to the timber-frame design that was added to it in the 1920s.

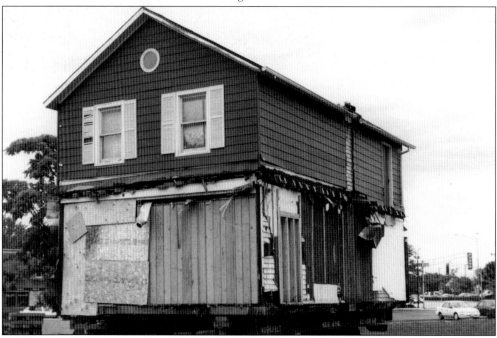

This photograph captures the moving of the Moehling general store in 1998. By the end of the 1990s, there was movement to develop this stretch of Northwest Highway and the Moehling general store was seen as a blighted building. While a number of people advocated the demolition of the building, a group of citizens, elected officials, and village staff worked together to move the building and save the first store in Mount Prospect for future generations to enjoy.

Just as some lost buildings can be found, others can be saved. The Moehling general store was moved to 10 South Pine Street and village staff, business partners, local students, and community volunteers pitched in and renovated the building. The additions were removed, the structure was brought up to code, and the building went through a process of adaptive reuse. The Moehling general store is now home to a very successful, locally-owned ice-cream store that proudly displays the history of the building and has become a real gathering place in the community.

ACROSS AMERICA, PEOPLE ARE DISCOVERING SOMETHING WONDERFUL. THEIR HERITAGE.

Arcadia Publishing is the leading local history publisher in the United States. With more than 3,000 titles in print and hundreds of new titles released every year, Arcadia has extensive specialized experience chronicling the history of communities and celebrating America's hidden stories, bringing to life the people, places, and events from the past. To discover the history of other communities across the nation, please visit:

www.arcadiapublishing.com

Customized search tools allow you to find regional history books about the town where you grew up, the cities where your friends and family live, the town where your parents met, or even that retirement spot you've been dreaming about.